Great American Road Trip

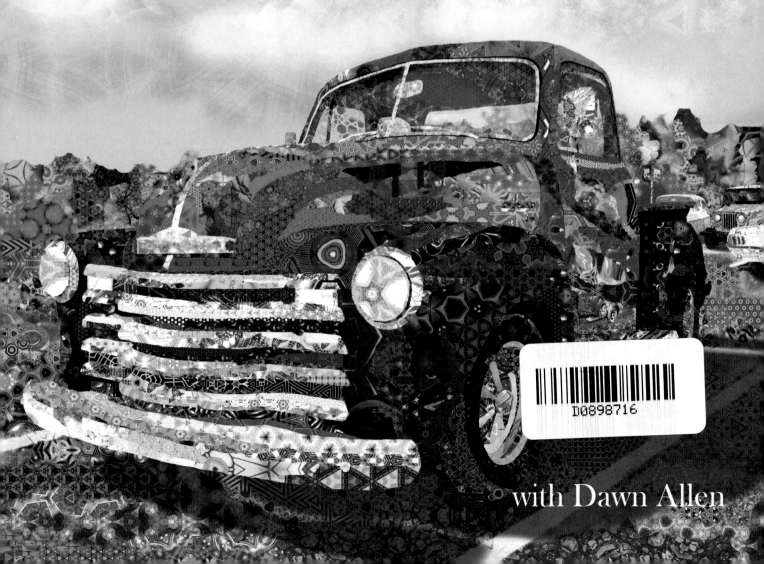

with Dawn Allen

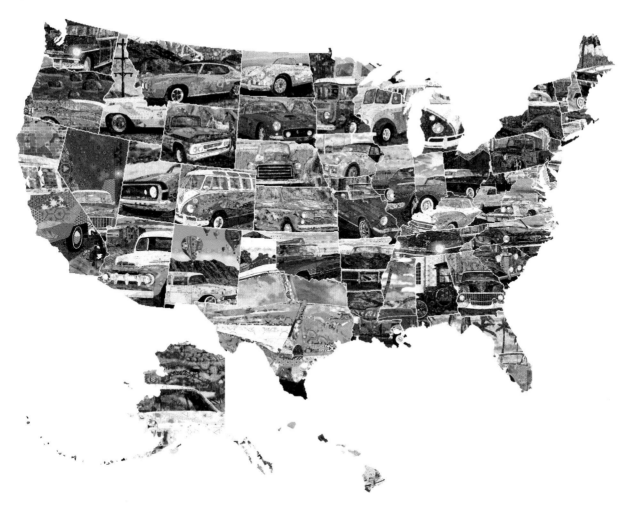

Copyright © 2020 by Dawn Allen
Written and Illustrated by Dawn Allen
Edited by Keala / Constance Lehmann
Quilts photographed by Jeff Bianchine

ISBN-13: 978-0-9816571-8-9
ISBN-10: 0-9816571-8-4
Dawn Allen: dawnallen.net
Dawn's Animal Connection: dawnallen.org
Westfield, MA

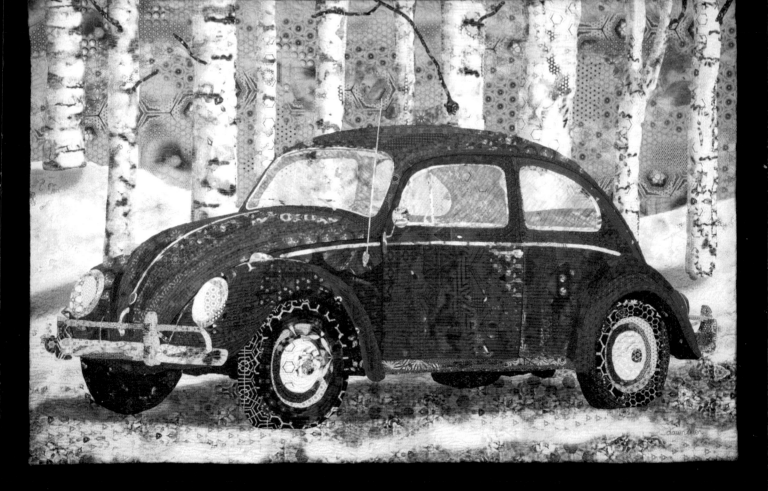

Winter Birch in New England, Fiber Art Quilt, 33" x 50"

My *Great American Road Trip* began in 2017 as an email series chronicling my artistic adventure and fantasy road trip. This book is a compilation of those original stories and fun state facts. At first, I was very determined to represent each state with the perfect piece (a backdrop that really showcased the state), but I ended up creating several pieces that could be any state and creating quite a few duplicate representations for the Northeast (because that is what I know best). I have decided to allow imperfection to rule the day, and here it is: a random travel selection featuring fun facts about our states and stories from my life and artistic inspiration. Welcome to my *Great American Road Trip*!

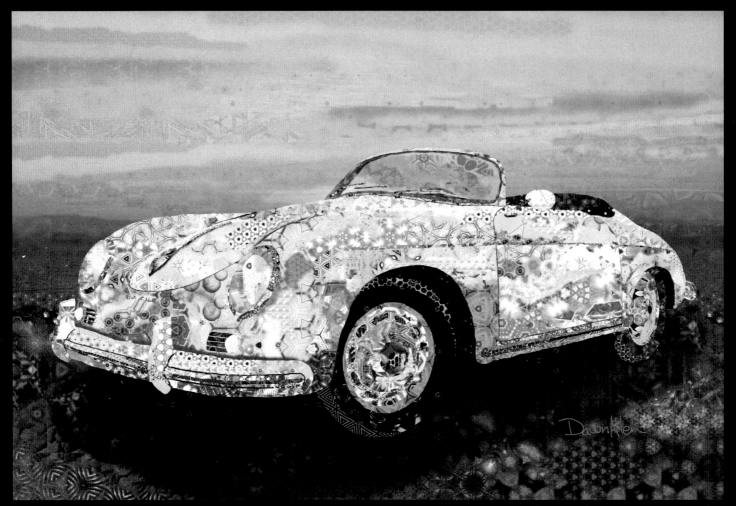

Peaceful Sky, Digital Painting

The *Great American Road Trip* started with me dreaming about a better car. I was driving my 12-year-old constantly-breaking-down car over the same old potholes, in the same town, taking my kids to and from school day after day. I had a good life with my husband, raising our two little girls, working, and taking care of our home, but I missed my old adventurous life when I was younger and traveled more.

I began creating with my art the kinds of cars I could only imagine having—beautiful vintage cars. I was born in 1974, so I was too young to see those classic cars filling the streets, but I love the way they look. I particularly love the curves.

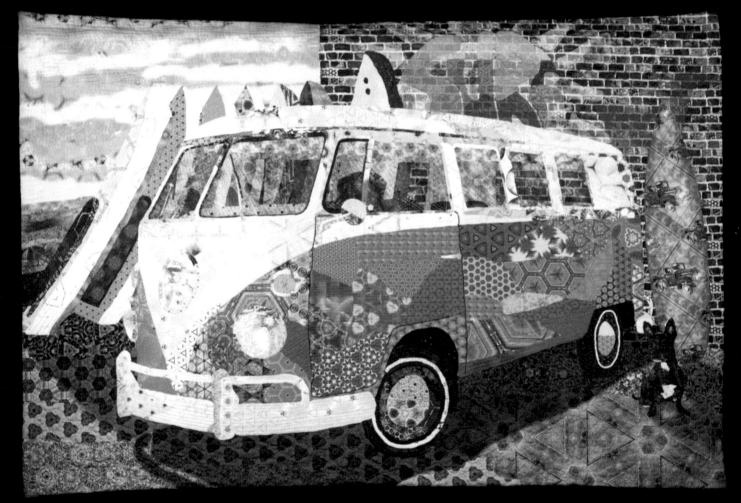

Surf, Fiber Art Quilt, 33" x 50"

Fantasizing about where I would go in those cars led me to create more scenic backdrops. My children were 7 and 9 at the time, and between work and the house and taking care of kids, I felt a little trapped. I couldn't just hop in the car and go, at least not without planning.

I really wanted to travel all over America, seeing how other people live and enjoying all of the natural wonders in each state. I kept painting and quilting more and more scenes from America, many I had never seen in person. After three years, I had created 50 art quilts and an additional 25+ digital paintings.

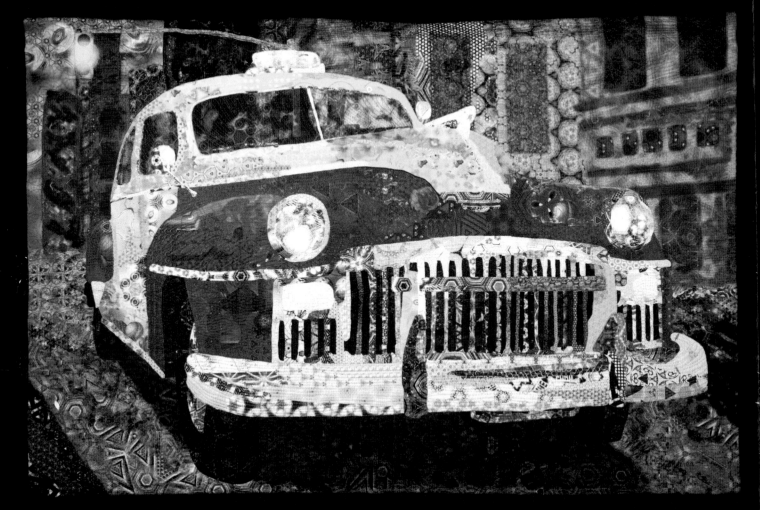

1948 Taxi in NYC, Fiber Art Quilt, 33" x 50"

I made my first quilt when I was 11, although I had already been sewing since I was about 5. For years I was obsessed with creating bed quilts, baby quilts, and decorative quilts for the wall. In 2003 I started putting more focus on making "art quilts." That means I approached the design like an artist—original concepts and techniques rather than traditional quilting. After I had children I was still quilting but less prolifically. I took a couple of years away from my studio to write my cookbook, *Culinary Creativity: Let your restrictions set you free*, and two children's books.

Then, when I was 39, after going to many doctors for my debilitating headaches, dizziness, and body aches, I was diagnosed with a vision issue, which, it turns out, I had had for my

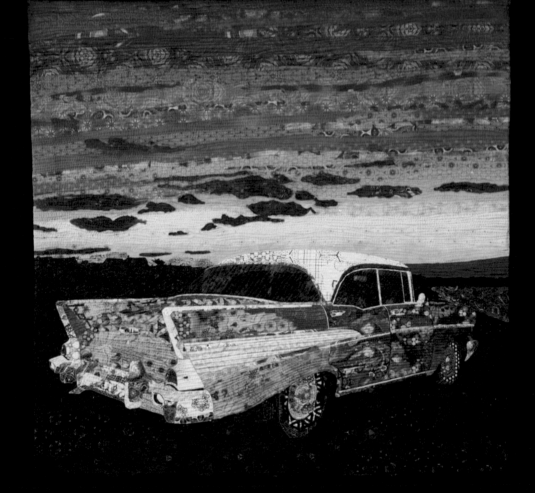

Sunset on the Beach, Fiber Art Quilt, 33" x 33"

entire life. I was seeing double (vertically), but my brain had suppressed the double vision. As a result, I had always had very little depth perception and a sense that everything I looked at was "swimming." Because I had been seeing that way since I was a child and didn't know otherwise, I thought my sight was "normal." I had always scored 20/20 on eye exams, so no one had questioned my vision.

The treatment for my condition was in two parts: prism lenses to bend the light to correct the double vision and vision therapy to condition my eyes to work together and my brain to process what I am seeing more efficiently and appropriately. This is not a fast process and is still ongoing, although I am doing very well lately!

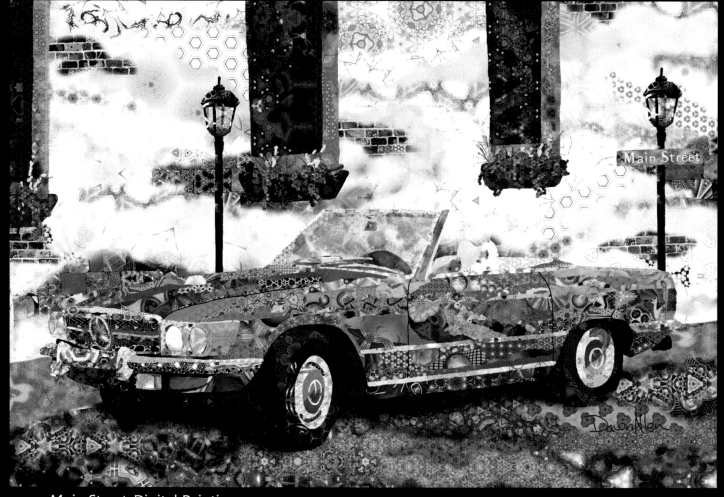

Main Street, Digital Painting

When I first got my prisms, I looked at art that I had made prior to my treatment (2014) and cried. I was so sad that it no longer looked the way I had originally believed it to be. I felt humiliated that all this time I had thought it looked one way, only to find out that it looked different to everyone else.

As I acclimated to my changing vision, I felt driven to make better art—something that could show people what I really see and share a little bit about what I used to see. It felt like a new opportunity to share my unique perspective. About six months into my treatment, I stepped into my studio for the first time in a year. I felt a great sense of focus and determination and

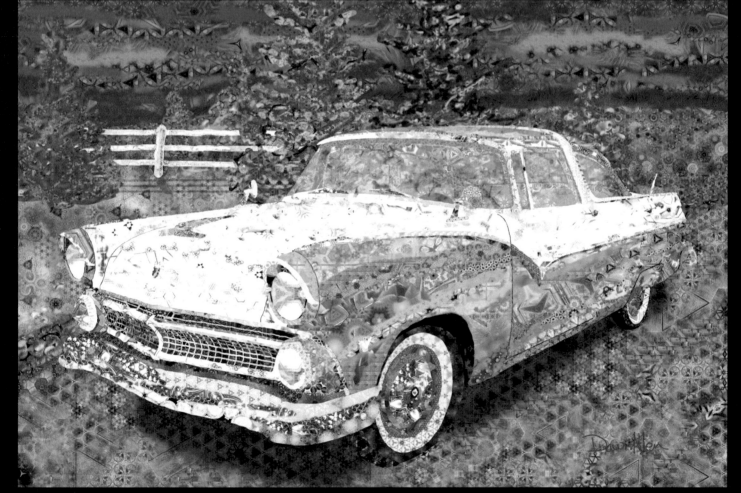

Horse Country, Digital Painting

have been in the studio every day since. I published *Garden Blooms*, a collection of the art I created from 2014–2016, to document that period of creativity.

I had been wearing glasses and going to vision therapy for a couple of years. Every few months my vision would change significantly and I would end up needing a less strong prism. This was a good thing! Part of what we were working on with my vision therapy was trying to gain depth perception.

One day after getting new lenses, I drove home and was shocked. I had an abrupt increase in depth perception! It was like the world had suddenly changed from a painting to a pop-up

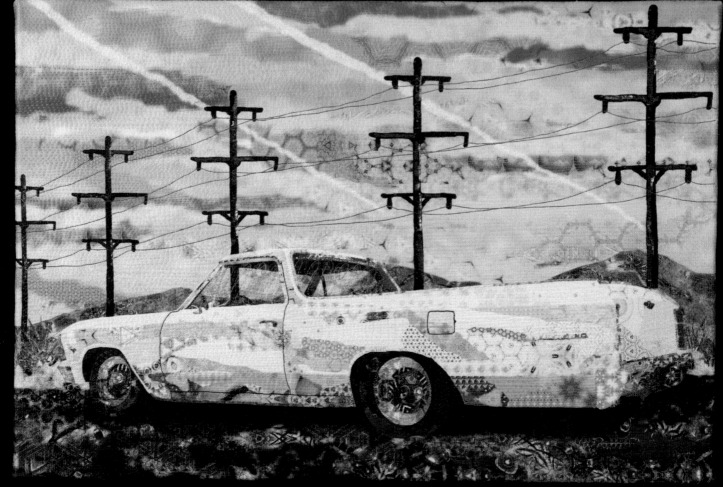

Power Lines, Fiber Art Quilt, 20" x 30"

book. The telephone poles really struck me as bizarre. They were barreling towards me, one after the other, as I drove down the road. I burst into tears and thought, "How can people live like this?" It seemed unbearable at the time. Now I don't even notice it; depth perception has become normalized for me.

In the past I had created my art quilts using commercially available fabrics. I liked the fun designs of each fabric peeking out of the larger "big picture," but I wanted even more artistic control and input. In 2015 I started designing my own fabrics on the computer and having them printed on fabric by a printing company.

Coastal Highway, Digital Painting

I quickly discovered that it didn't make sense to print the fabric and then cut it up and sew it back together when I could simply design it all as one digital painting. I began drawing scenes of vintage cars and animals on the computer using my digital fabric designs.

I created my own innovative technique for digital painting. I start with photos of nature and interesting textures and then use various techniques to transform the photos into repeating patterns on the computer. I save the patterns in color groupings to use as my custom paint palette. Using a stylus pen and pad, I "paint" with my patterns. I use a reference photo (of the subject) to guide my drawing.

Lake Tahoe, Fiber Art Quilt, 20" x 30"

When the digital painting is complete, I have the artwork printed on fabric and finish the piece in the style of an art quilt. Three layers—top fabric, batting, backing—with free-motion stitching over the top. Sometimes I print the digital painting on metal or photo paper to hang on the wall with no quilting involved.

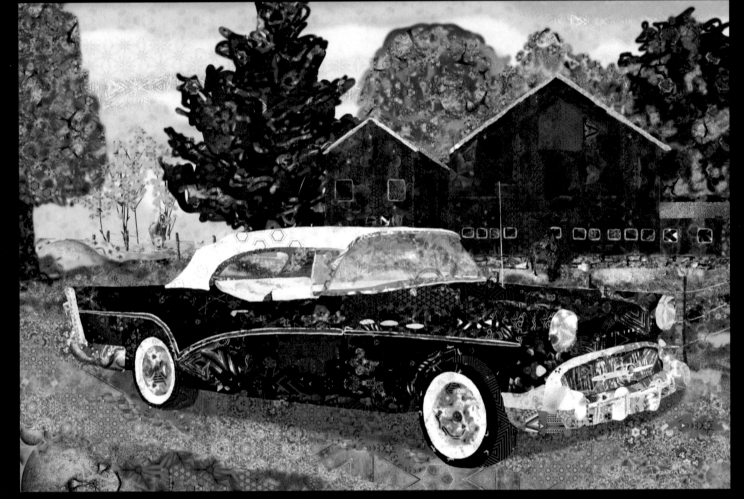

Red Barn, Digital Painting

The ability to "copy/paste" is one of the fun aspects of being a digital artist. I can take parts of one painting and copy them into a new painting. In "Red Barn" I copied two horses I had already drawn for other projects and pasted them into the composition.

I knew I could do the same with the cars, too, theoretically; however, when I put a bunch of my cars into one drawing to create a "parking lot," it failed. Most of the cars had been drawn from different perspectives (levels), and the result of combining them in a piece ended up looking very wonky.

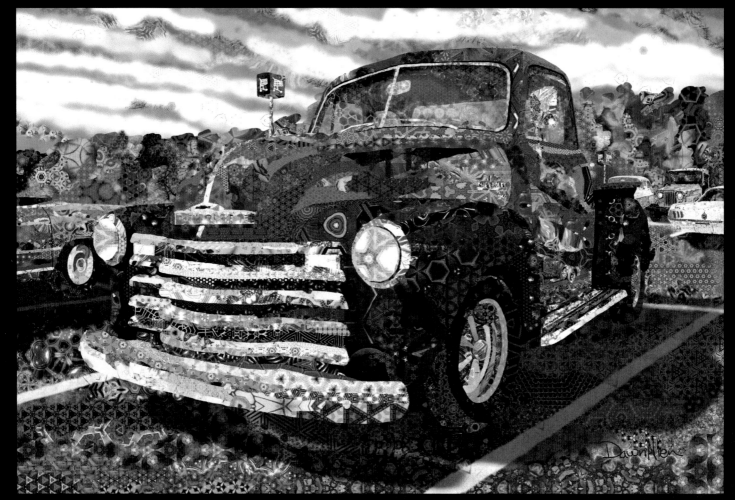

Parking Lot, Digital Painting

I circled back to the idea of having several cars together in a parking lot and got good results—in the piece aptly titled "Parking Lot"—by carefully choosing cars that share a similar perspective. My husband had spotted this truck in a large retail chain parking lot, and I used the photo as a reference fairly literally. I liked the idea of combining elements of a modern parking lot with cars from various eras—almost as if they were setting up for a vintage car show.

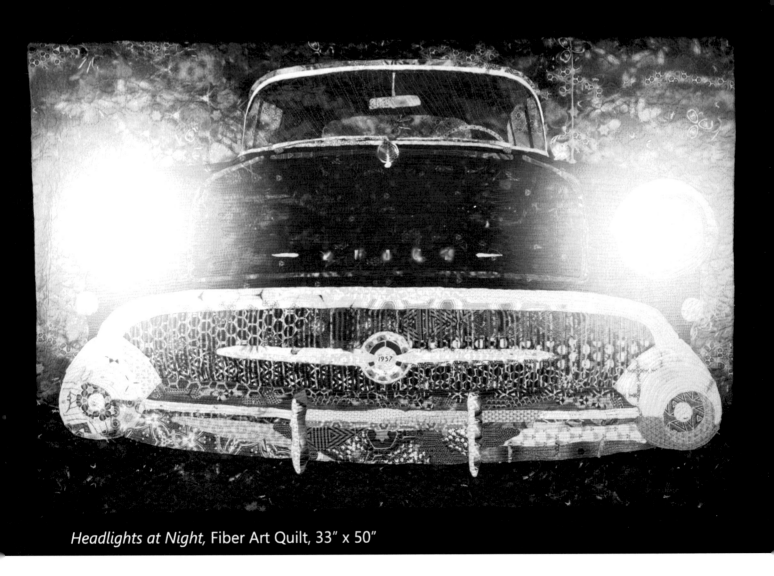

Headlights at Night, Fiber Art Quilt, 33" x 50"

There are several pieces in the *Great American Road Trip* in which the headlights appear to be "on." I was very interested in experimenting with headlight effects, and it turned out to be a rather simple technique. First I created the entire digital painting of the car and background. Then I used a large diffused digital paintbrush tool and added one big white spot. I lowered the opacity slightly so that it was partially see-through.

I had "Headlights at Night" hanging in a show, and a little girl came up and said, "Mommy, the lights are so bright they are hurting my eyes!" I took that as a sign that my optical illusion was a success! One of my favorite show memories.

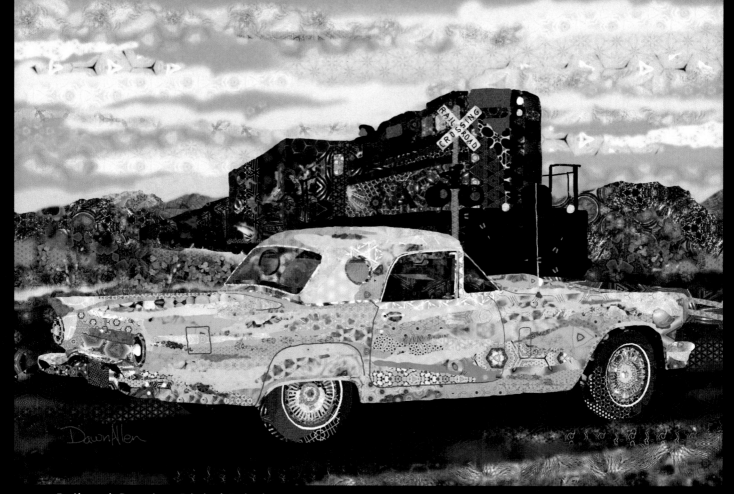

Railroad Crossing, Digital Painting

West Virginia

I generally refer to Massachusetts as my home state, but my first nine years were spent on a remote mountaintop in West Virginia. I remember driving down steep winding hills behind coal trucks with my dad ranting about the trucks. Driving anywhere was a big deal because of our location. There was a small town that we could get to for the bank and laundry about 25 minutes from our home. Often, just as we would be about to enter town, a train would cross the road—and that's what inspired this piece.

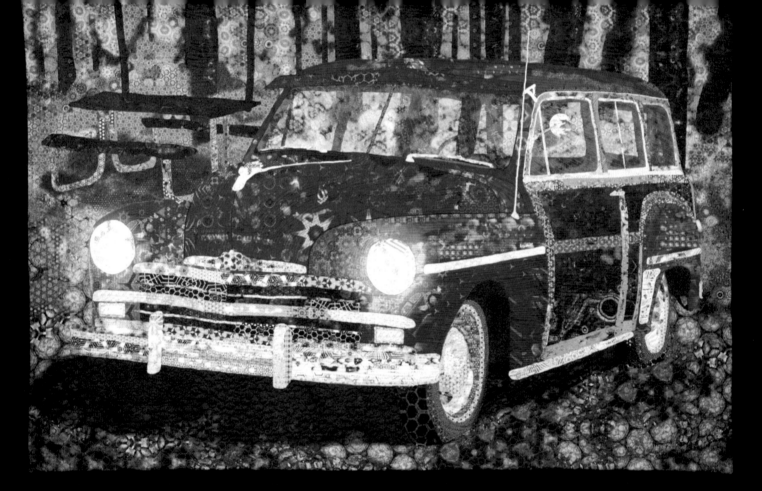

Woody Goes Camping, Fiber Art Quilt, 33" x 50"

Sometimes my parents would take us to Cool Springs, a bizarre "tourist trap" full of knickknacks, toys, guns, and a small diner all in one. I loved getting breakfast there. Picking out which flavor of jelly I would use from the table-top jelly holder was my first order of business. Pancakes were a good choice.

We lived in a funky log cabin made from reclaimed wood. It was five-sided and started out with no indoor bathroom. Even though I was very young, I still remember when we got our indoor bathroom in the late 1970s.

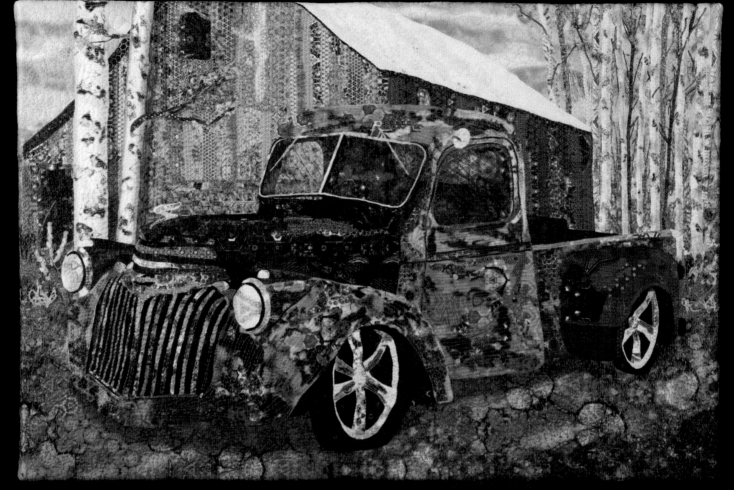

Old Truck, Old Farm, Fiber Art Quilt, 20" x 30"

Pennsylvania

My aunts live there, and I have many great memories of visiting for holidays and going to Sesame Place (as a child and later as a parent). I love the countryside in that area with its beautiful rolling hills and old barns.

My aunts lived in a suburb of Philadelphia on a cul-de-sac. We visited when I was about 3, and, apparently, I was very accustomed to not having indoor plumbing, so I went out and used the front yard. They were horrified and have never let me forget the story!

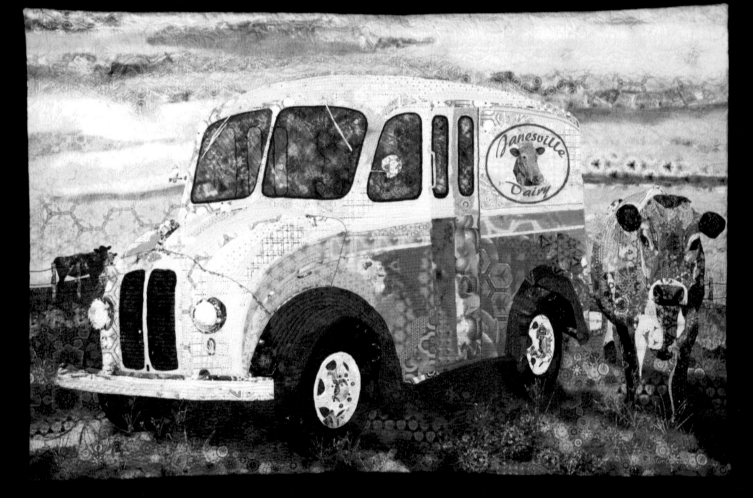

Milk Truck, Fiber Art Quilt, 33" x 50"

Wisconsin

Both of my parents grew up in Wisconsin. We would drive there to visit my grandparents, first from West Virginia and later from Massachusetts—a very long drive from either.

My dad grew up in Janesville, and I named the imaginary dairy in this piece in honor of his hometown. He insists that cheese from Wisconsin is far superior to any other cheese. He mail-orders his cheese direct from a dairy and always gets a bag of (orange) cheese curds.

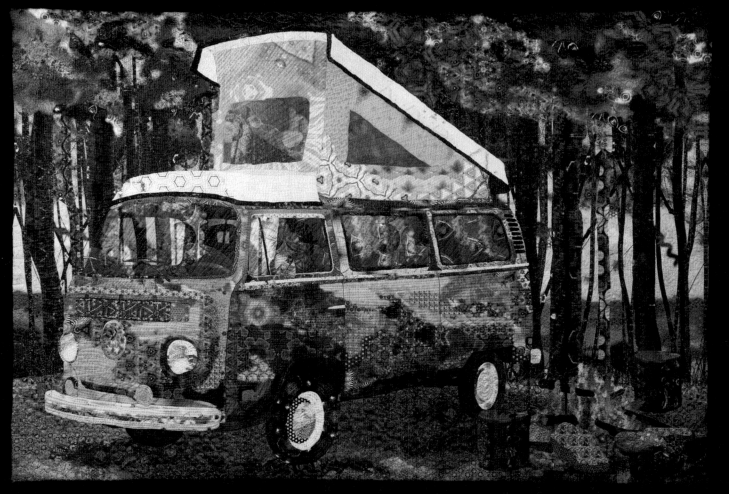

Campfire, Fiber Art Quilt, 33" x 50"

Minnesota

My mother's father owned an auto-body shop and loved fixing up vintage cars. Of course, back in the 1960s "vintage" referred to Ford's Model T and such. He and my grandmother also loved to camp. They lived near the Minnesota border and often would go on camping/fishing trips in their bus. My grandfather once drove the bus right onto the lake for ice fishing—and it fell through the ice!

My husband also had a bus like this growing up. I created this piece for him with imagery of camping because those are his best memories of the vehicle.

20

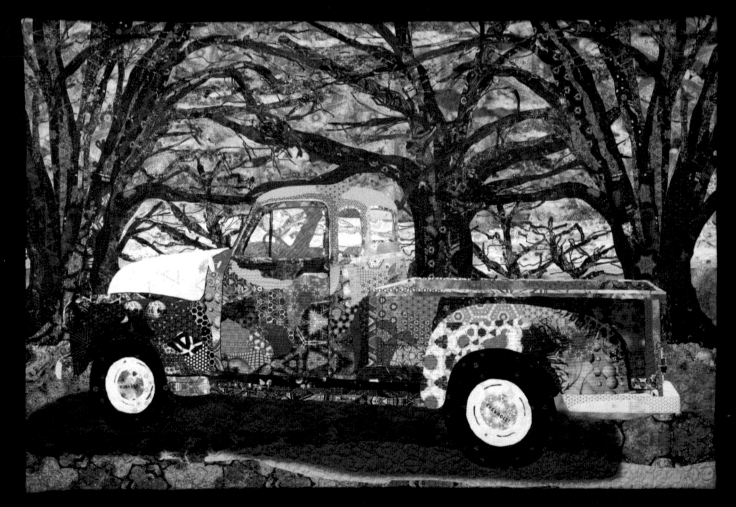

Louisiana Oaks, Fiber Art Quilt, 33" x 50"

Louisiana

I was only in Louisiana once, when I was about 5. I remember two things very distinctly about that trip. One memory was watching *The Wizard of Oz* for the first time and hiding behind a couch because it is a terrifying movie! A better memory, and my favorite, is of the magnificent oak trees covered in hanging moss—they made a life-long impression on me. I often think about those trees, and someday I hope to go back and visit again. They are the inspiration for "Louisiana Oaks."

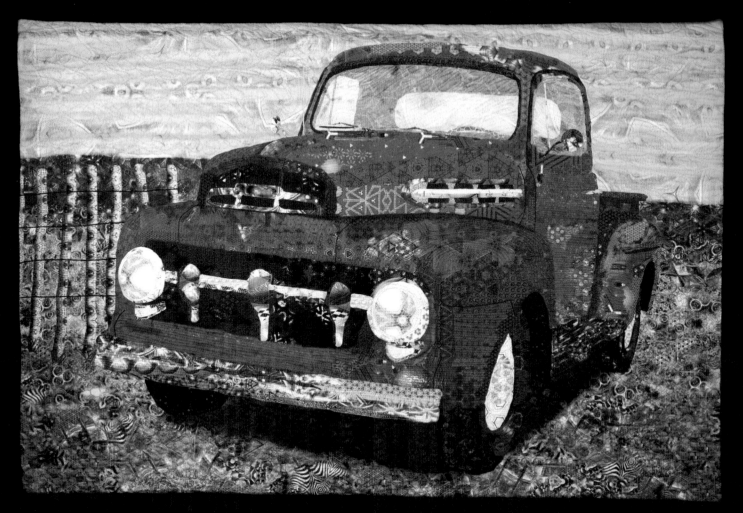

Red Truck on Cape Cod, Fiber Art Quilt, 33" x 50"

Massachusetts

I have lived in Massachusetts since I was almost 9. My family home is in the Berkshires (western Massachusetts), which is a beautiful hilly, forested area. Each summer my parents took us to Cape Cod for a vacation. We were incredibly lucky that a family friend allowed us to use their home up on the bluffs overlooking the bay. It is amazing what a completely different environment the Cape is only a few hours away from the Berkshires. Cape Cod has beautiful sand dunes, clearwater ponds, miles of beaches, and beautiful cedar shake houses everywhere.

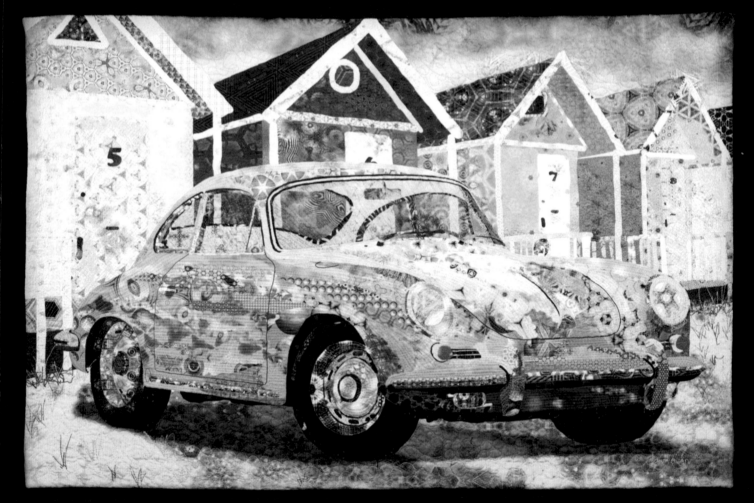

Beach Cottages, Fiber Art Quilt, 33" x 50"

We have continued the tradition of going to the same house with my mother and our children. It is such fun to take my kids on the vacations of my childhood.

Maryland

I love Maryland's coast, and most of all I love visiting the wild ponies of Assateague Island. I went there as a teenager, and it was such a thrill. On one particular day, in the parking lot of the beach, a family was unloading their picnic from the trunk of their car. A pony walked up, grabbed a 2-liter bottle of soda, and held it up in an attempt to chug it—he seemed to know what he was doing! The cap was on, so he gave that up and took one of the grocery bags and sauntered off.

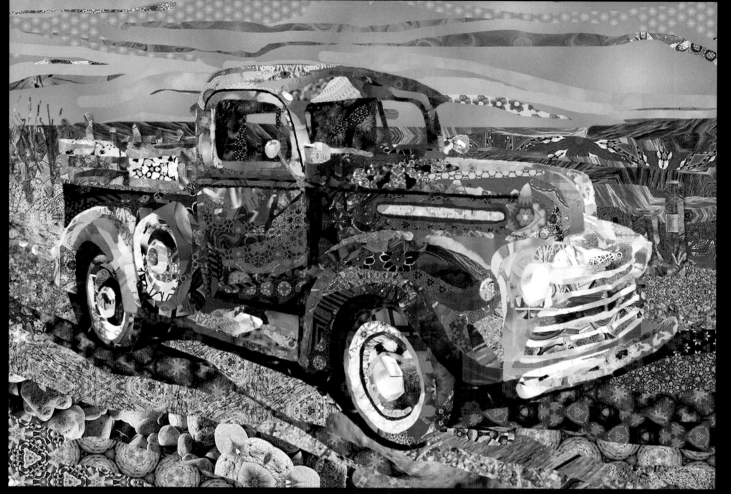

Red Truck, Digital Painting

You aren't supposed to interact with the ponies, but they have a way of inserting themselves into the human experience. One day we had our windows open in the car as we waited in line to exit the park when a pony stuck her head in the window. The ranger yelled, "No petting the horses!" Ha! Tell that to the pony!

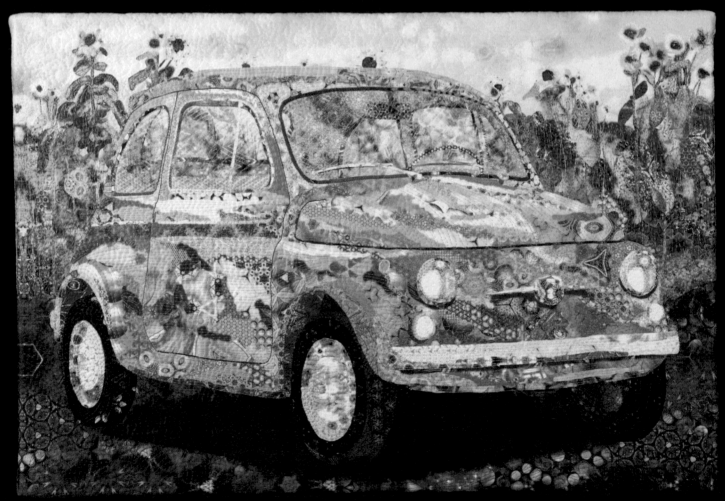

Sunflower Field, Fiber Art Quilt, 20" x 30"

Kansas

When I was in college, I drove from Massachusetts to spend the summer in Boulder, CO. Driving through Kansas was amazing. It was my first time ever being in the plains, which are really beautiful. We passed through miles of sunflower seed crops! Wow! It was such a sight with the tall huge flowers looming over the field, all facing the same direction, bright yellows with dark green stalks. I promised myself that I would someday go back to see the miles of sunflowers again, but I haven't … yet.

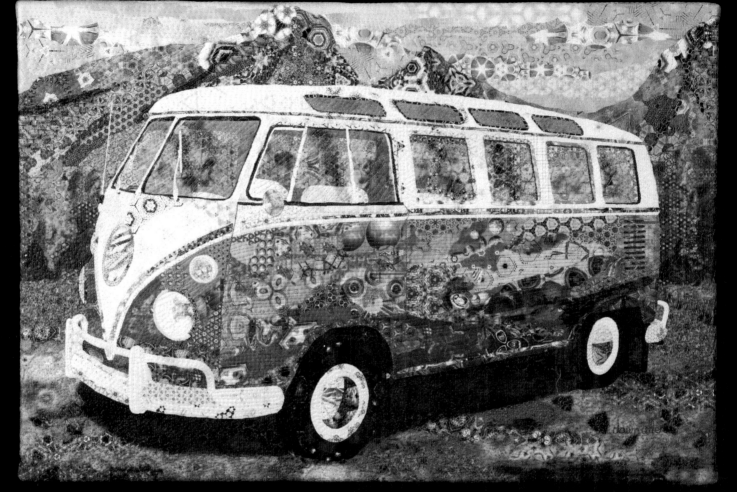

Colorado Mountains, Fiber Art Quilt, 20" x 30"

Colorado

Arriving in Colorado I was impressed on a whole new level. It was my first time seeing the Rocky Mountains, and I loved it there. I got a job working at a horse stable and spent the rest of my time hiking. I could climb the iconic Flat Irons directly from our rental. A few times we drove up into the mountains and hiked in the snow peaks. I have never seen such beautiful wildflowers as I did on those mountaintops.

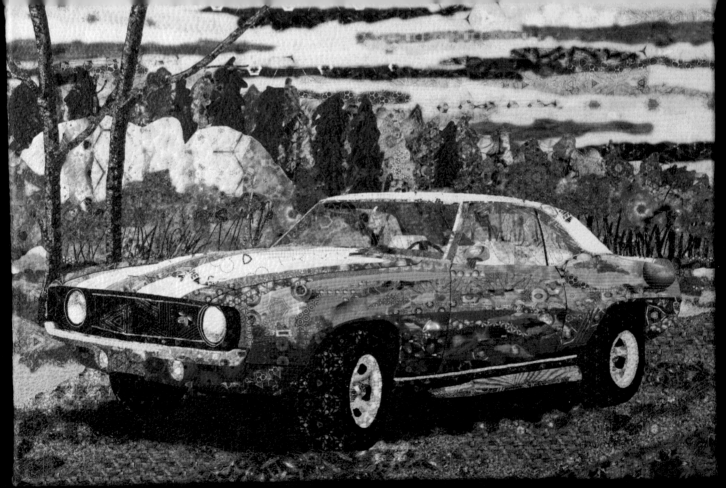

Maine Wilderness, Fiber Art Quilt, 20" x 30"

Maine

I went to Bates College in Maine for several years (before transferring to Goddard College in Vermont for my final three semesters). I chose Bates primarily because I wanted a small college and wanted to compete on an NCAA Division 1 cross-country ski team. Being on the ski team meant that I went roller-skiing and running all over the back roads and forests near Lewiston, ME, which is where I got the inspiration for this piece.

My freshman year on the ski team was very busy. I was on the varsity team, and we traveled to what they called Carnivals every weekend, Friday–Sunday. During one race it was so cold

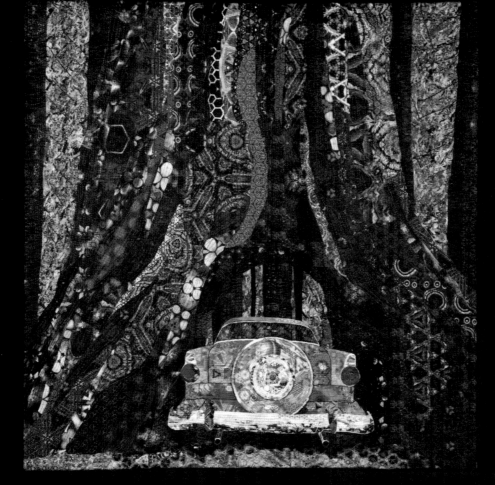

In the Redwoods, Fiber Art Quilt, 33" x 33"

that after I finished the 15-kilometer race my ski binding was frozen closed. One of my teammates had to carry me inside to thaw by the fire!

California

I have lived my whole life on the east coast, but I am very fortunate to have traveled quite a bit in California. My favorite trip to the Golden State did not involve any cars at all! When I was 22, a friend and I went on a bicycle trip from San Francisco to Canada and then back down to Seattle. We pedaled about 1,000 miles. We hiked in the redwoods and even rode our

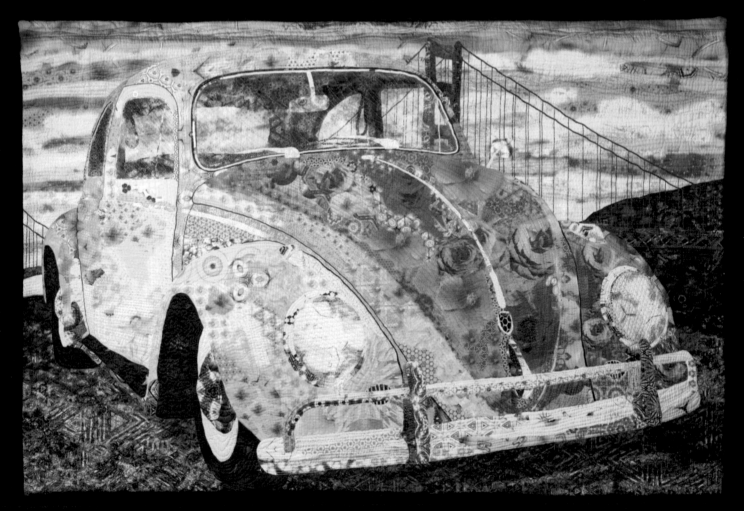

Visiting the Golden Gate Bridge, Fiber Art Quilt, 33" x 50"

bikes through a redwood tree! We enjoyed miles of Pacific coast and visited the Hoh Rain Forest in Washington State.

I will always remember the first day of the trip. We had ridden only 3 miles, and a guy at a grocery store was asking about our trek. We told him how far we planned on going, and he laughed out loud! I guess we looked weak? I was so confident in my ability to do the entire ride. I had no doubt at all. I have always been like that, ready to take on big projects—such as creating 75 pieces for this vintage car series!

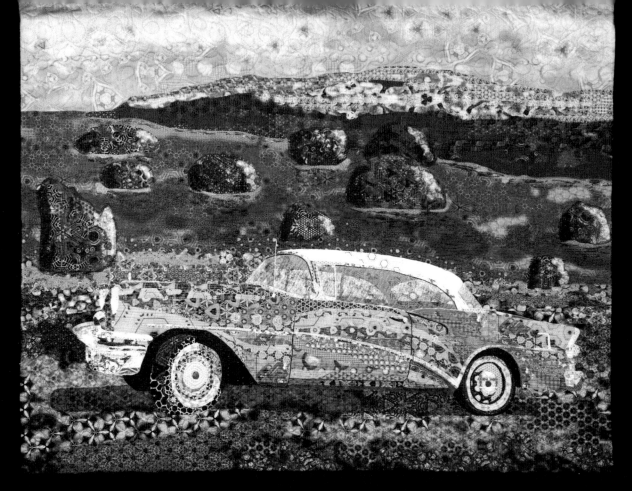

Cruising on the Oregon Coast, Fiber Art Quilt, 33" x 42"

Oregon

I love the Oregon coast with the beautiful "sea stacks" and foggy weather. One of our favorite stops on the bike trip was in Tillamook where we pigged out on free cheese and chocolate samples. Really, the entire bike trip might have been an excuse to eat; we stopped at Dairy Queen in Tillamook, too. Well, we stopped at all the Dairy Queens for dipped cones. I developed amazing "urban tracking" skills. I could tell by the trash on the side of the road how far it would be to the nearest Dairy Queen. I had a formula for how long it takes to eat a cone while riding in a car and at what speed. Sure, it is depressing to see trash in the grass, but the silver lining was that it would be only another hour of biking and then a dipped cone!

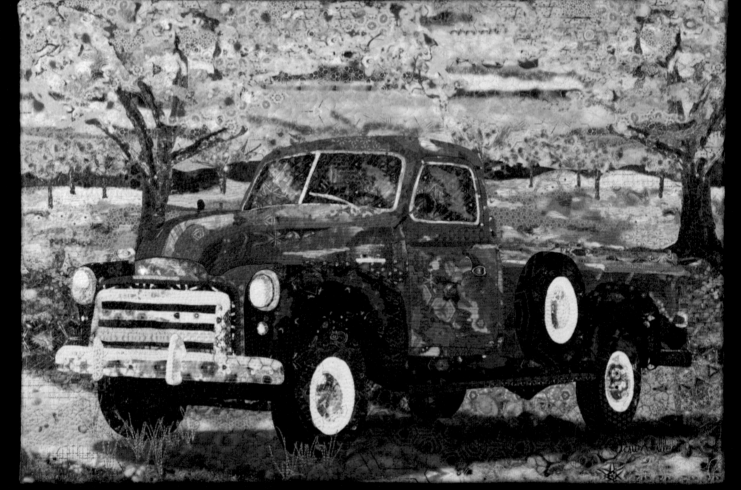

Apple Orchard, Fiber Art Quilt, 20" x 30"

Washington

I went with a cliché for this one ... an apple orchard. Washington was one of the states I rode my bike through. We didn't actually see any apple orchards in Washington, but I know I certainly have eaten plenty of apples from the state. On a side note, when I spent a semester studying abroad in Sri Lanka where they have tons of amazing tropical fruits, they also sold Washington Red Delicious apples in the fruit market. Those apples were expensive and considered exotic!

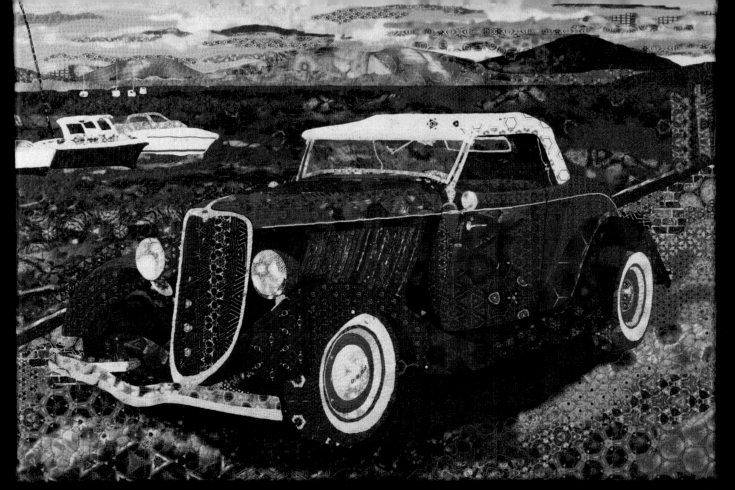

Burlington at Sunset, Fiber Art Quilt, 20" x 30"

As I was writing my *Great American Road Trip* email series (which became this book), I researched the states with which I was less familiar and sprinkled in fun facts about the states or weird old laws. So you will see some of that as we continue our adventure.

Vermont

I stumbled upon a trivia page that states, "Ben & Jerry's Ice Cream company gives their ice cream waste to the local Vermont farmers who use it to feed their hogs. The hogs seem to like all of the flavors except Mint Cookie." Why wouldn't pigs like mint?

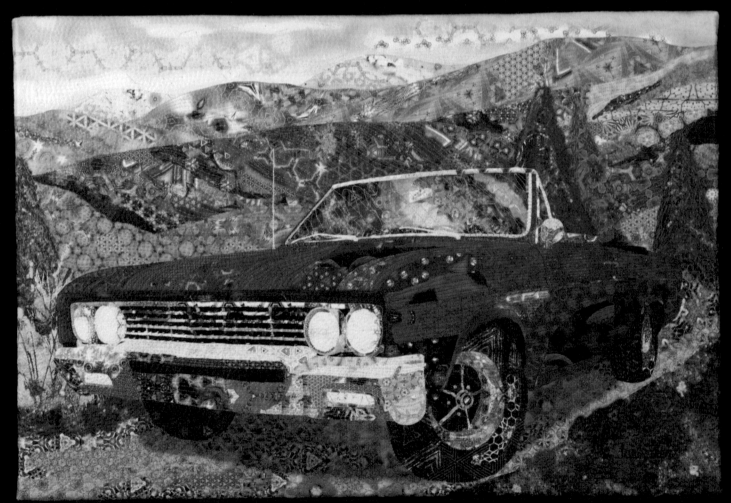

Mountains of Vermont, Fiber Art Quilt, 20" x 30"

I have been to Vermont many times. In fact, I graduated from Goddard College in Vermont. However, I never really attended school there because I was in their remote learning program.

Most recently I had the pleasure of being a vendor with my art at the Vermont Antique & Classic Car Meet in Waterbury. I booked several commissions at the show, and two of them selected Vermont-inspired backgrounds: "Burlington at Sunset" and "Mountains of Vermont."

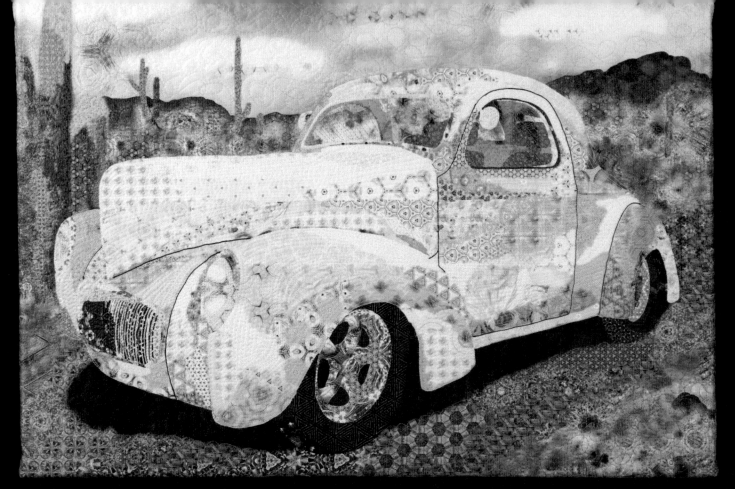

Desert, Fiber Art Quilt, 20" x 30"

Oklahoma

The freest I ever felt in my life is when I drove from Massachusetts to New Mexico in my first car all by myself. I was heading out to a place for an internship. Everything I owned was packed into my little 3-cylinder Geo Metro. It was the best drive ever and the beginning of a very adventurous year.

That road trip took me through Oklahoma. When I was a teenager I had a horse named Okeema. Supposedly, she was previously the horse of Arlo Guthrie. I never knew for certain, but it made sense as I drove through Oklahoma and saw a sign that said something like,

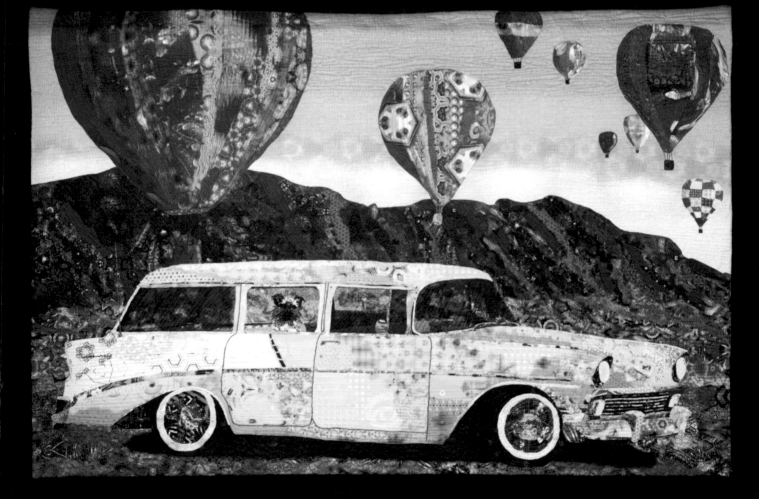

Balloon Festival, Fiber Art Quilt, 33" x 50"

"Town of Okemah, home of Woody Guthrie"! Of course, I took the exit, and right there in front of me was a gas station whose roof sported a full-sized statue of a horse—with the same colors as my Okeema. I mean some coincidences are just too amazing!

New Mexico

I lived in Pojoaque, near Santa Fe, for one year (through Goddard College) learning Linda Tellington-Jones special method of working with animals. I also have been fortunate enough to return for several visits over the past 20 years because I really fell in love with New Mexico. And speaking of love, my husband and I got engaged there!

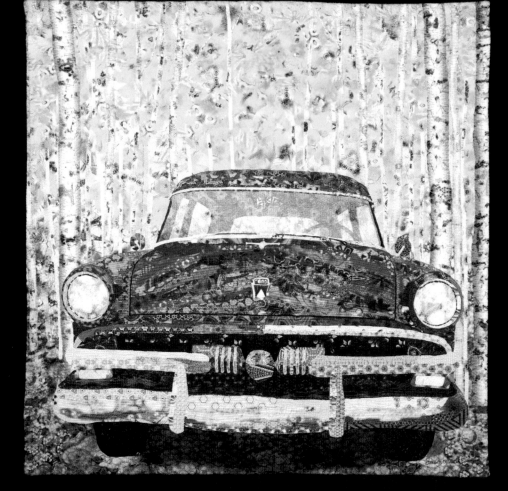

Aspens in New Mexico, Fiber Art Quilt, 33" x 33"

I have so many favorite places and memories in New Mexico. The aspen forests in the mountains above Santa Fe are a stunning place to hike and ski. I love the desert, mesas, rivers, and White Sands. Oh, that place is amazing! White Sands is a desert with pure white sand that looks exactly like snow. So cool!

Linda let me borrow one of her Icelandic horses while living there, and he and I loved to ride out in the mesas. He enjoyed trotting right down the center of the "river" (not much water unless it was raining). We would splash along under the big blue sky, and it was heavenly.

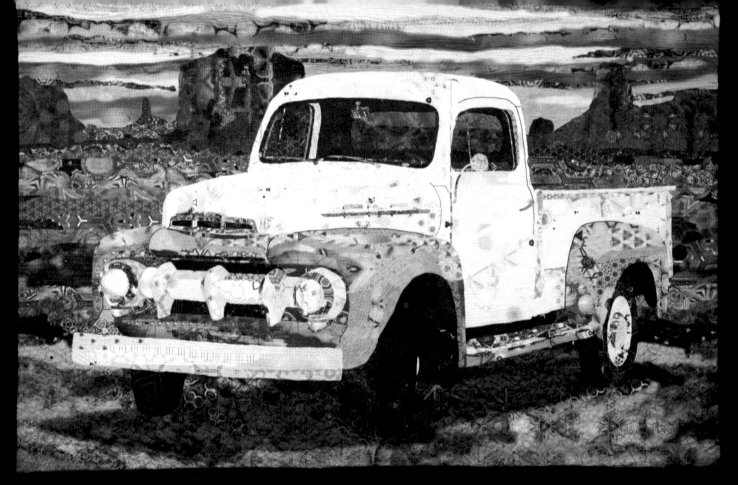

Red Rocks, Fiber Art Quilt, 33" x 50"

Arizona

During an August many years ago, I had a layover in the Phoenix airport. I wanted to see the city, so we took a shuttle and walked around a bit. I can honestly say I have never felt so hot. It was like standing in front of an open oven door. Wow!

At a later date, I was fortunate enough to drive through the northern part of the state in the winter. I saw some beautiful sights but didn't have time to explore. I will definitely go back in the cooler season!

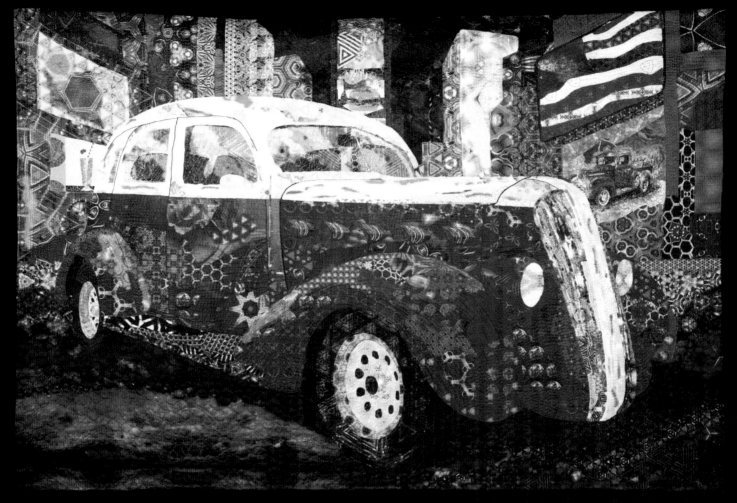

Times Square, Fiber Art Quilt, 33" x 50"

New York

I will be honest here, New York City terrifies me. A few years ago I had a panic attack on a bridge—hyperventilated and burst into tears—and I wasn't even the driver! It all started when I was a kid and my dad and I had gone into the city to deliver some furniture he had made (he is a talented woodworker). His truck broke down on a bridge, and the chaotic traffic was frightening!

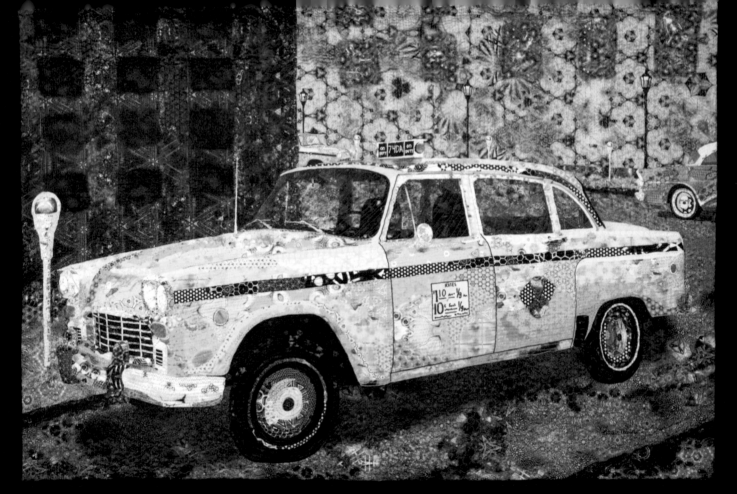

Checker Taxi in NYC, Fiber Art Quilt, 33" x 50"

About a year after creating "Times Square," I had the chance to test myself in NYC again. Dad went for cancer treatment in Manhattan, and I went to stay for several days on three different occasions. I even drove there by myself and parked in Manhattan! I made my peace with the city but maintain my preference for rural living.

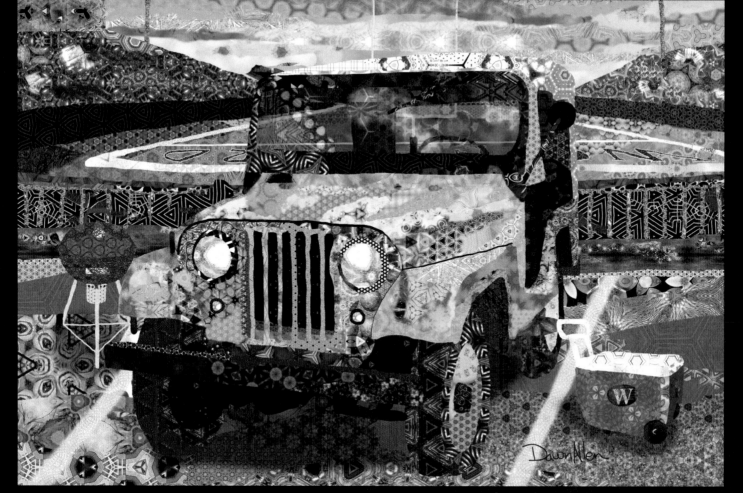

Tailgating, Digital Painting

South Carolina

I created "Tailgating" for my brother-in-law. He was a football player at Wofford College in South Carolina. I did some research and drew the vehicle in the school colors of gold and black and put a "W" on the cooler to represent tailgating at a Wofford game.

North Carolina

My brother and sister-in-law live in North Carolina, so I have had the opportunity to see parts of the state. The part I have yet to visit is the coast, which I hear is very beautiful. In general, it seems like a really great climate, milder than our Massachusetts winters.

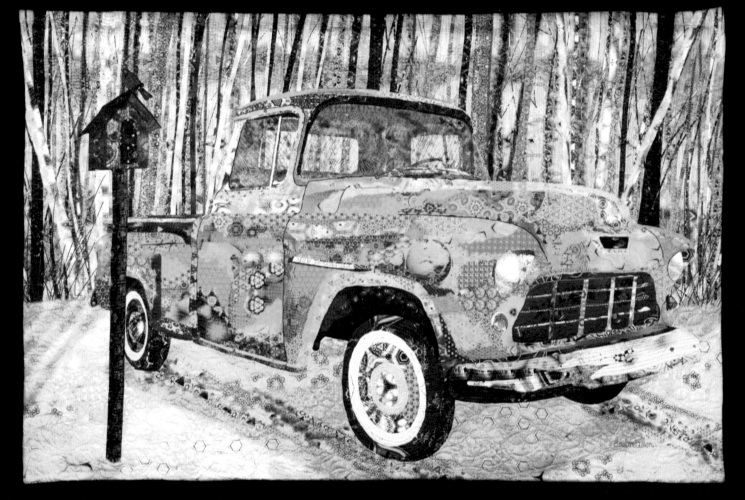

New Hampshire Winter, Fiber Art Quilt, 33" x 50"

New Hampshire

One of the beauties of New Hampshire is the mountains. There are several big ones. If you live in New England, you have most likely seen the bumper stickers, "This car climbed Mt. Washington." I love to hike, so I always found it hard to be impressed by a car climbing a mountain. However, I was impressed to learn: "The highest wind speed recorded at ground level is at Mt. Washington, on April 12, 1934. The winds were three times as fast as those in most hurricanes." Wow! Of course I presume the cars didn't climb the mountain on that day! Cars have been making the climb since the early 1900s.

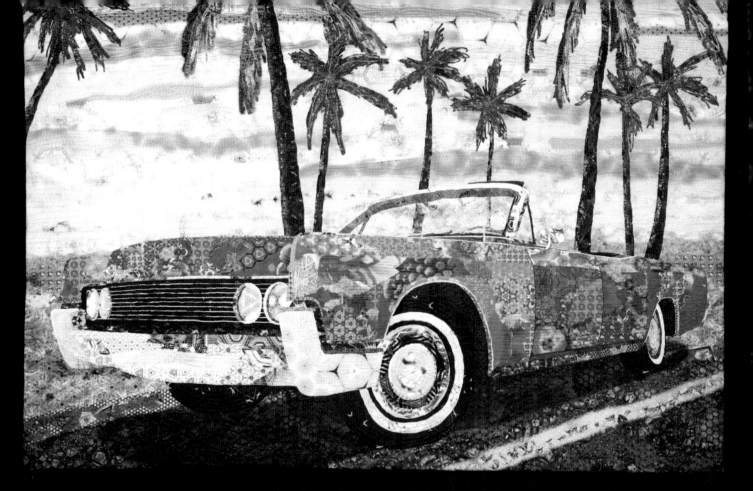

Cruising in Miami, Fiber Art Quilt, 33" x 50"

Florida

When I was 12 my mom took us camping in Florida (near Disney World) with my grandparents. We had packed for warm weather, but they had a freak cold snap—it was 30ºF with 50-mph winds! One night we had baked potatoes at the picnic table and at least four humans sitting there when a raccoon hopped up, snatched a hot potato, and scampered off—so bold! There were also tons of armadillos grunting and squealing around the camper all night. I was totally freaked out!

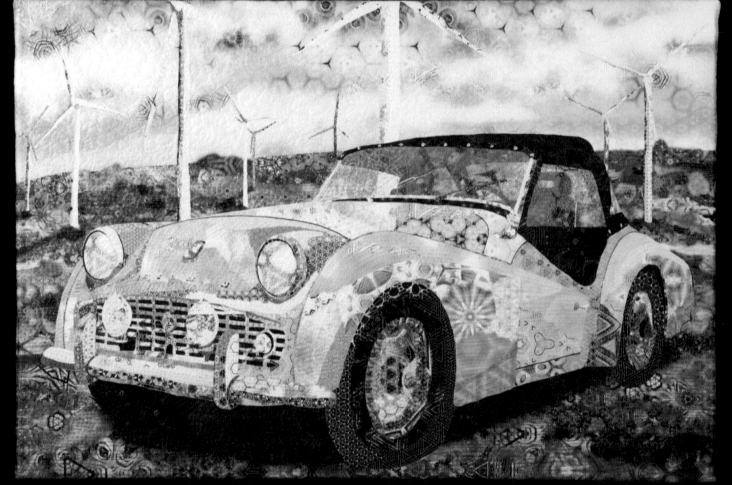

Wind Farm, Fiber Art Quilt, 20" x 30"

So, when it came time to take my own kids to Disney World, we booked a single room at a hotel. We arrived on my daughter's birthday, and the Disney resort surprised us with a free room upgrade. We walked into a huge living room, dining room, 2-bedroom, 3-bathroom, executive suite! Wow! It was an amazing vacation.

Iowa

I think wind farms are beautiful. I love the all-white, almost eerie structures casting long shadows as they stand watch over miles of small hills. I have seen wind farms in California popping out through the valley fog, but, sadly, I have not had the chance to visit Iowa.

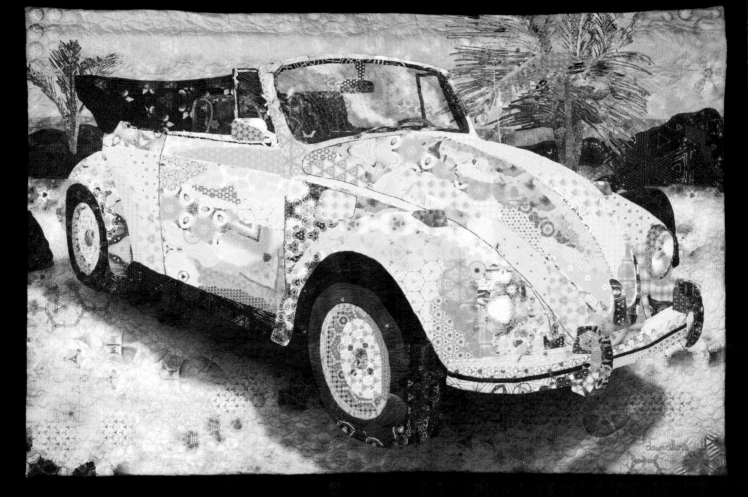

Hawaii, Fiber Art Quilt, 33" x 50"

When I was researching wind farms for this piece I learned that Iowa is the second largest state in wind energy production (after Texas) and has several large wind farms.

Hawaii

When I first met my husband, he had already started planning a trip with his college friend to Hawaii. So, when he went about a year later without me, I technically shouldn't have complained, but I will admit I pouted a little bit! Twenty-two years later I still haven't been to

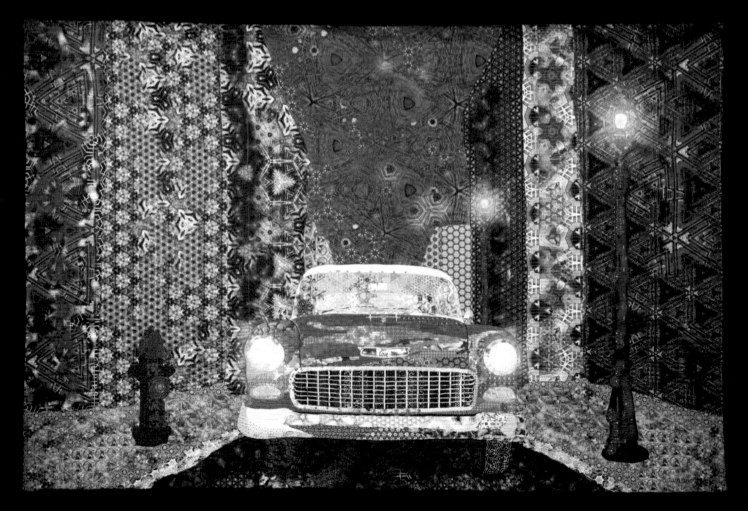

Night Out in Las Vegas, Fiber Art Quilt, 33" x 50"

Hawaii. I used a photo he had taken on his trip as a reference for the background of my "Hawaii" piece. I love the contrast of the white sand and the lava rocks.

Nevada

This was my first painting for the Great American Road Trip. After this one, most of the pieces had the car occupying as much of the frame as possible. The later pieces also tended to have a bit more detail.

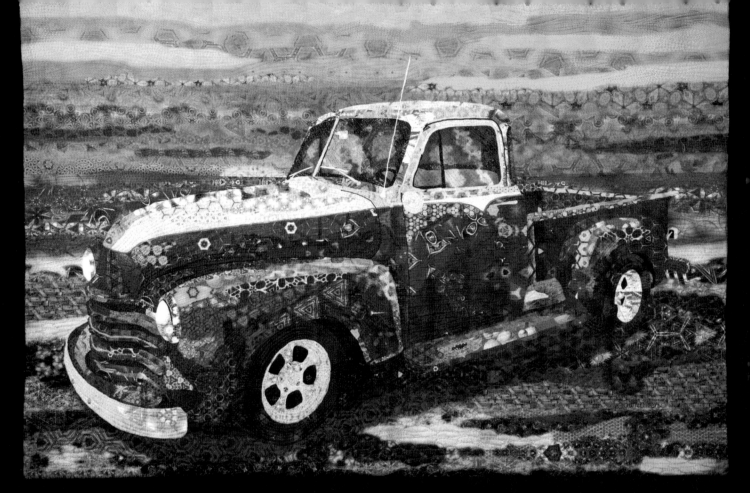

Virginia Beach, Fiber Art Quilt, 33" x 50"

I have been to Las Vegas, and it really is much brighter and louder than this image suggests! However, I was inspired by the idea of a celebrity pulling into a back alley between the big casinos to sneak in a back door to attend a private party.

Virginia Beach

Once when I was in Virginia Beach for a conference, I saw the most magnificent moonrise. It was one of those huge orange moons rising up out of the ocean. I will never forget that sight. This piece is loosely inspired by the colors of that night but depicts a sunrise rather than a moonrise.

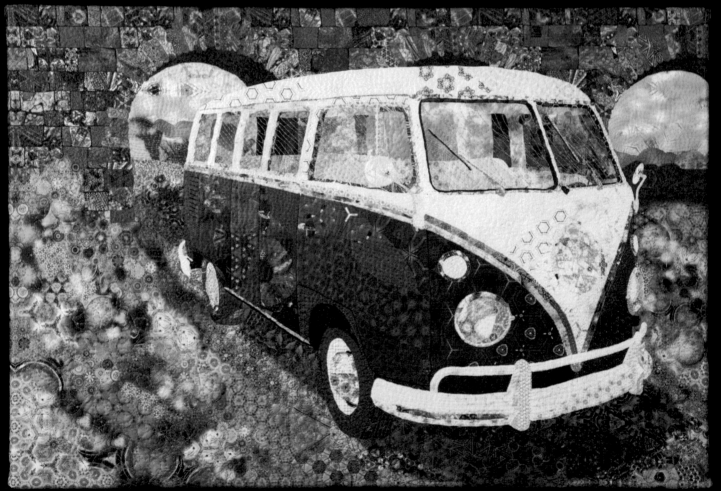

Railroad Bridge, Fiber Art Quilt, 20" x 30"

Michigan

As I mentioned, my grandparents and extended family all live in Wisconsin, so for my childhood travels, Michigan was a drive-through state.

I created "Railroad Bridge" for my dad. He and my mom had a red bus back in the late '60s. They fit the hippie stereotype, having attended Woodstock and all!

Anyway, I wish I had a bus like this now. My husband and I would love to go road tripping in one!

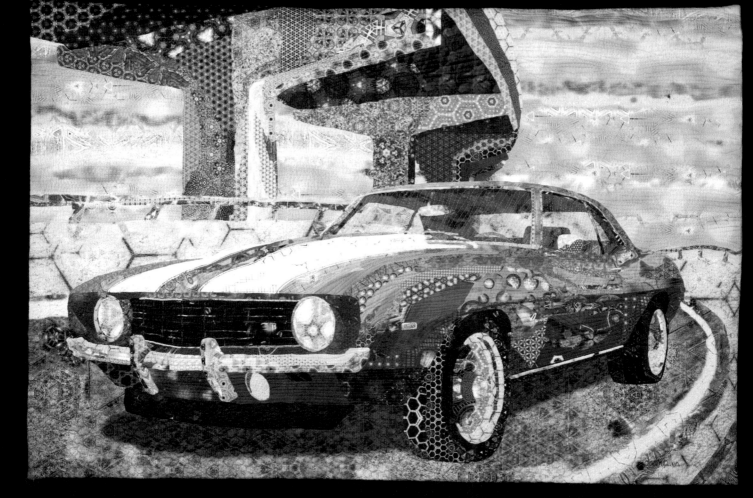

Overpass, Fiber Art Quilt, 33" x 50"

Ohio

When I was a kid with my family driving out to Wisconsin, I always felt like there were miles of boring highway through Ohio. I wish I could go back in time and enjoy the adventure all over again. The thing about road trips as a kid is that they always sounded like a fun idea, but then, after few hours, the tedium of riding in the car would set in. In these modern times my kids can watch videos in the car. We make them turn off the video when there are important sights to see, but you know kids ... sometimes they whine about it. I know I did my share of whining on those long car trips, and now here I am nostalgic about epic road trips!

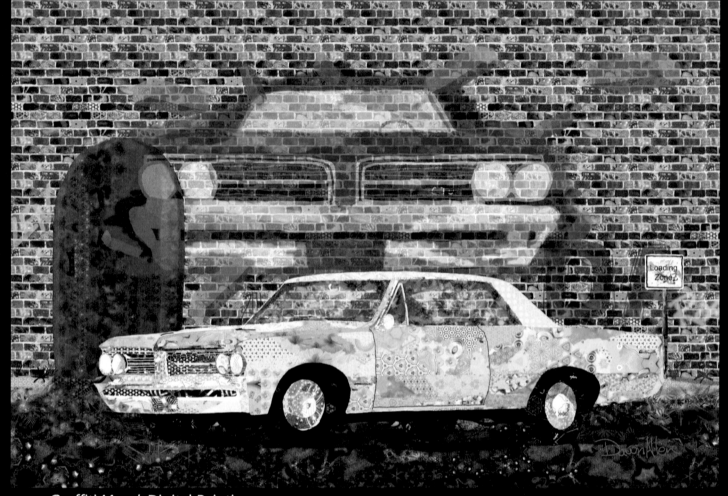

Graffiti Mural, Digital Painting

Illinois

I attended a wedding at the botanical gardens in Chicago, which was beautiful. I didn't have a chance to get familiar with much of the city or the state for that matter.

I did notice that Chicago had some great graffiti art. I am obsessed with graffiti and find some of the large murals absolutely breathtaking. It is something I enjoy looking at, but I have never attempted spray paint art myself!

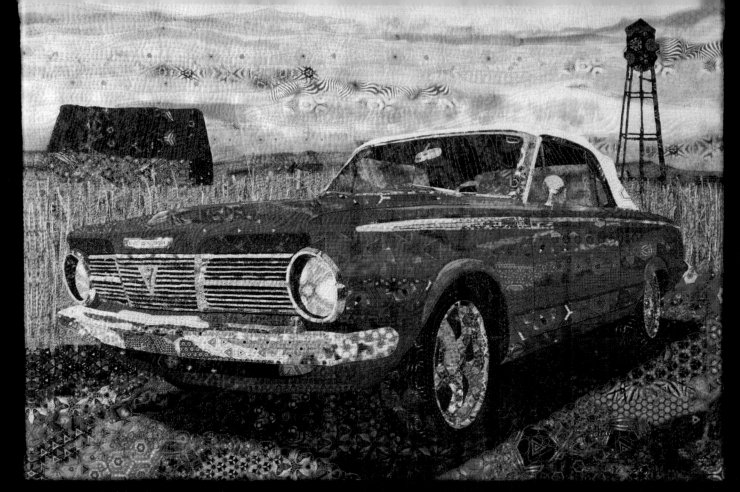

Corn Field, Fiber Art Quilt, 20" x 30"

Nebraska

Nebraska is one of the top three corn-producing states. As I was creating this piece, I was imagining driving through an old farming community past miles of corn fields.

When I was little my parents would grow a row of corn in the vegetable garden. I loved to go out and eat it raw straight off the stalk. It is incredibly sweet that way but has a little bit of a sticky, milky texture. My parents eventually gave up on growing corn because the raccoons kept stealing it.

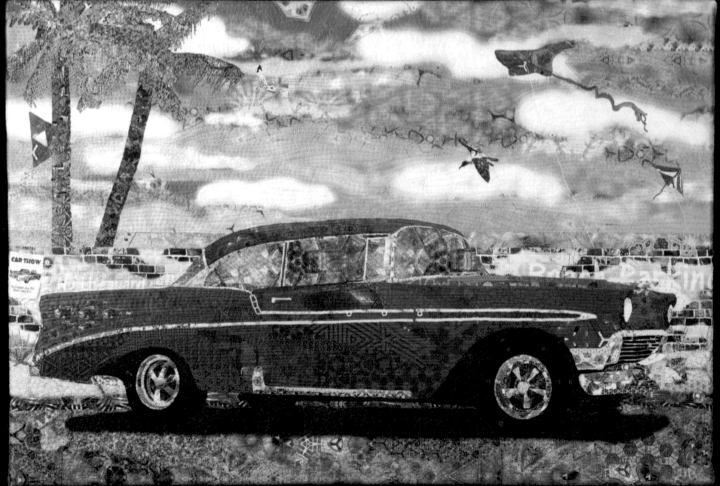

Kite Day, Fiber Art Quilt, 20" x 30"

Raccoons weren't their only problem. When the sugar snap peas were ripe in the garden, I would pretend to be a rabbit and hop through, taking bites of the peas right off the vine. My poor mom probably had no idea what was eating her plants!

Alabama

Alabama is a state I know very little about, although I would be curious to explore it more deeply. I did find it interesting to learn that Alabama's state constitution is the longest and most amended state constitution! They have a law against wrestling bears. That one's a keeper—no need to amend it!

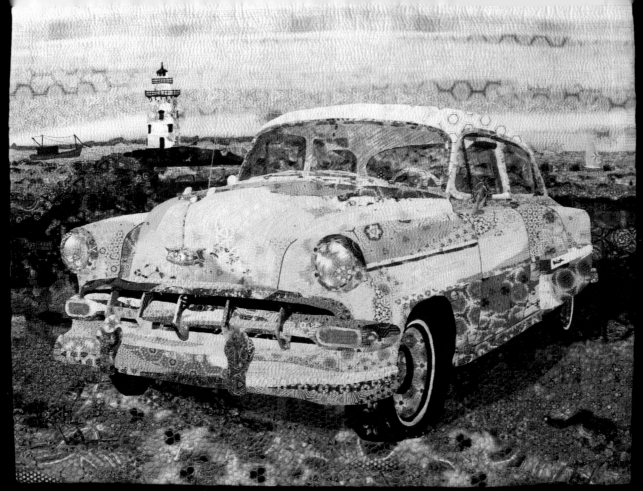

Lighthouse Playhouse, Fiber Art Quilt, 30" x 40"

Connecticut

A wealthy Connecticut family converted a lighthouse into a playhouse for a couple of lucky kids! When I read the story of that 130-year-old lighthouse, I wished in that moment that I could be those children. Or better yet, I thought of the fantasy art studio I could build in there instead! Fortunately for me, I have a very small but super-effective studio in my basement that my husband created for me. He is the best!

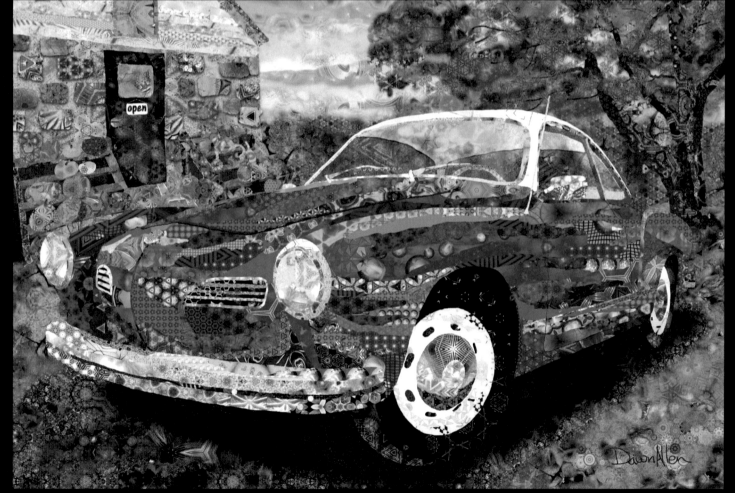

Farm Stand, Digital Painting

Arkansas

I feel like geography was taught to me in such a cold way in school. I memorized my states and capitals and knew where they all were on a map, but I never learned what was in those states. For example, I didn't know anything about Arkansas. Even having driven straight across the state (twice), I had no idea what I was missing until I did an internet search. Now I can't wait to go there and visit the Ozarks!

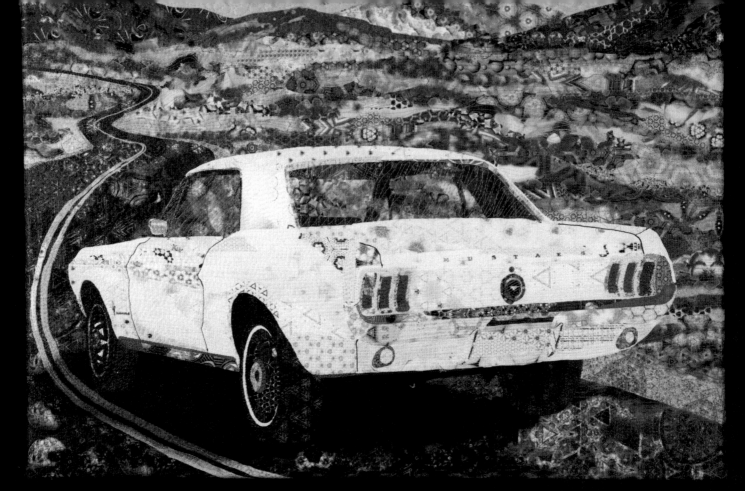

Denali National Park, Fiber Art Quilt, 20" x 30"

Alaska

Denali National Park in Alaska is home to the highest mountain peak in North America, with a summit elevation of 20,310 feet above sea level. I have never been higher than 12,000 feet. I can't imagine how thin the air is at over 20,000!

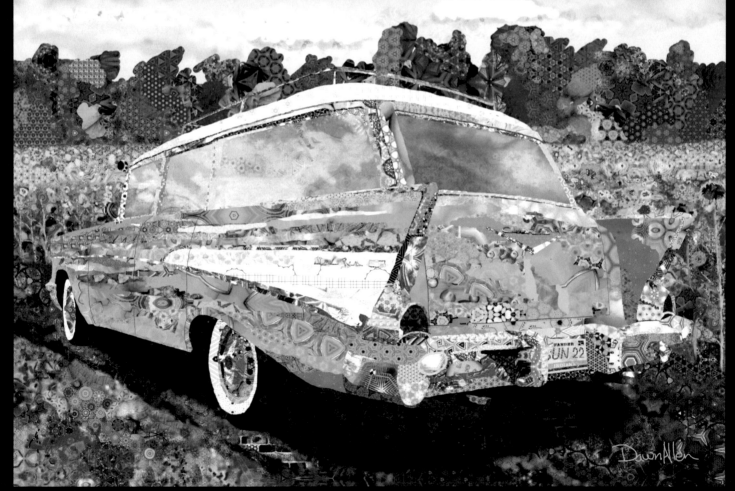

Indiana Sunflower, Digital Painting

Indiana

I have driven through Indiana but didn't know all it had to offer until I searched online. I can't wait to go visit during sunflower season because apparently there are quite a few beautiful farms.

Alternatively, going at Christmastime could also be wonderful. They have a town, Santa Claus, that receives over a half million letters at Christmastime—all addressed to Santa of course!

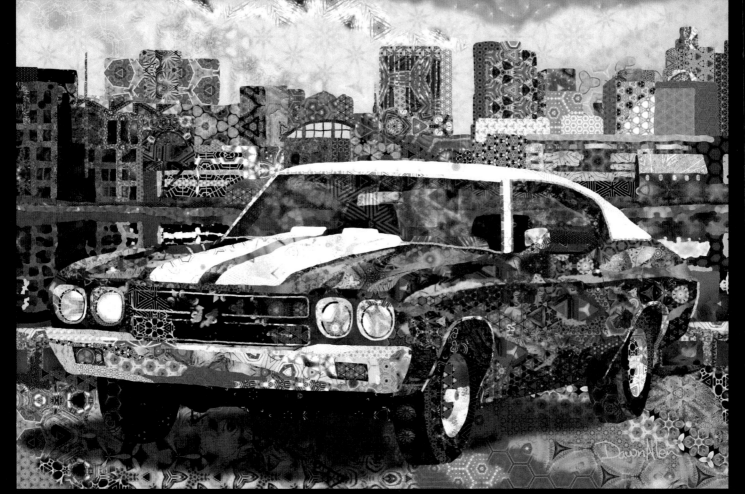
Delaware, Digital Painting

Delaware

Delaware may be small (the second smallest state with only 35 miles at its widest point), but apparently they have very fast internet (random fact). I have heard a lot of people talking about retiring in Delaware because they have no sales tax and very low property taxes. I am so attached to my friends and family I can't imagine moving to save on taxes, but maybe I could go there for a shopping spree sometime!

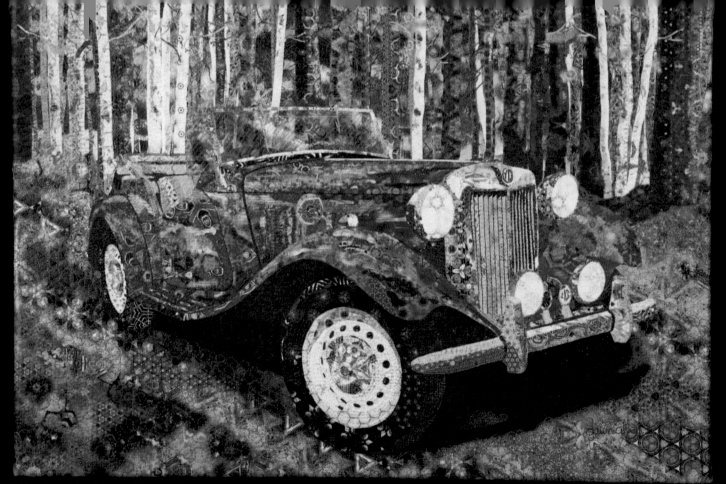

Sunday Drive, Fiber Art Quilt, 20" x 30"

Idaho

Oh, Idaho, how I would love to visit! You are one of the states I have not yet seen, and when I researched I saw what I was missing. On my must-see list: Craters of the Moon National Monument (very old lava rocks creating a lunar-like landscape), Shoshone Falls (I love waterfalls), and any of the beautiful mountain lakes.

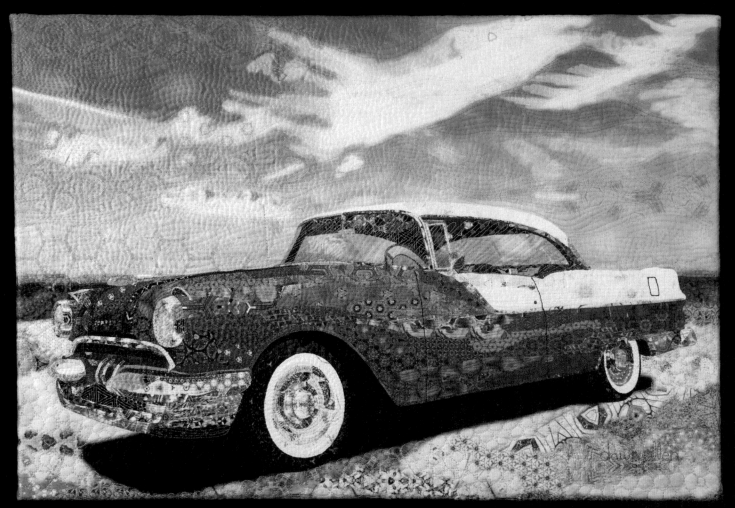

Blue Sky, Fiber Art Quilt, 20" x 30"

South Dakota

Badlands National Park in South Dakota consists of nearly 244,000 acres of rock formations blended with the largest, protected mixed-grass prairie in the United States. It also contains fossil beds dating back 23–35 million years. The more National Parks I research, the more I want to jump in my car and go! I can't wait to see the Badlands someday.

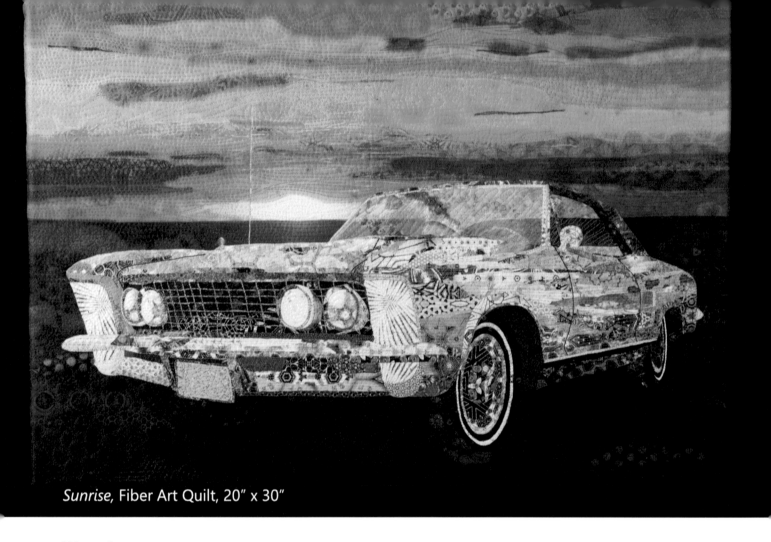

Sunrise, Fiber Art Quilt, 20" x 30"

Wyoming

Of course, the main attraction in Wyoming for me is the beautiful scenery, but they also have some funny—but practical—laws. "It is illegal to wear a hat that obstructs people's view in a public theater or place of amusement." Yes! I hate not being able to see. And, "All new buildings that cost over $100,000 to build must have 1% of funds spent on artwork for the building." I am not sure that this law is fair, but as an artist I kind of like it!

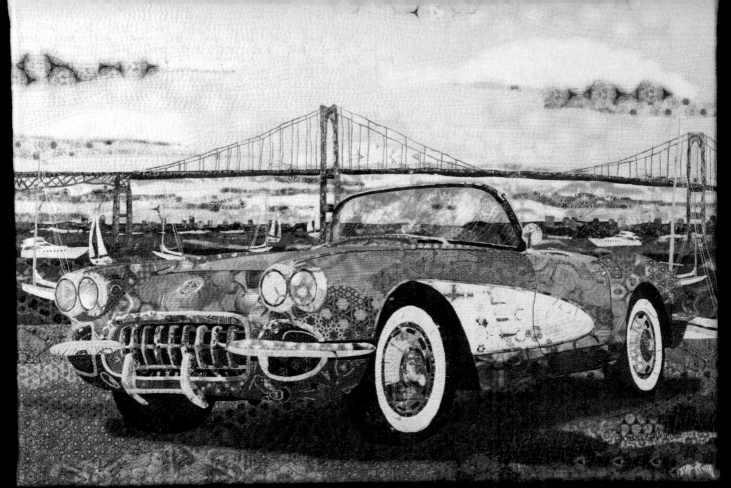

Newport Bridge, Fiber Art Quilt, 20" x 30"

Rhode Island

A client commissioned me to create this piece. When I asked the couple where they like to drive the car, they replied, "Newport, Rhode Island." As luck would have it, I had just been to Newport the week before visiting a vintage car museum! I had taken quite a few photos and knew this iconic view of the Newport Bridge would make the perfect background for the piece.

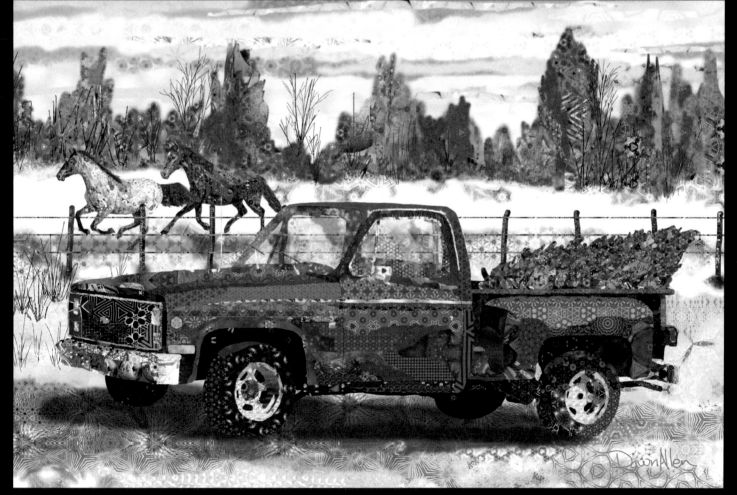

Christmas Memories, Digital Painting

Kentucky

Kentucky is home to 130 limestone caves. Personally, caves are not my thing, so I am not particularly interested in this stop on the road trip. I've been to Carlsbad Caverns in New Mexico, and while the stalactites were stunning, I found the place very unsettling, and the air felt odd; also I am really scared of bats! But if you love caves, then Kentucky has a big one called Mammoth Cave waiting for you!

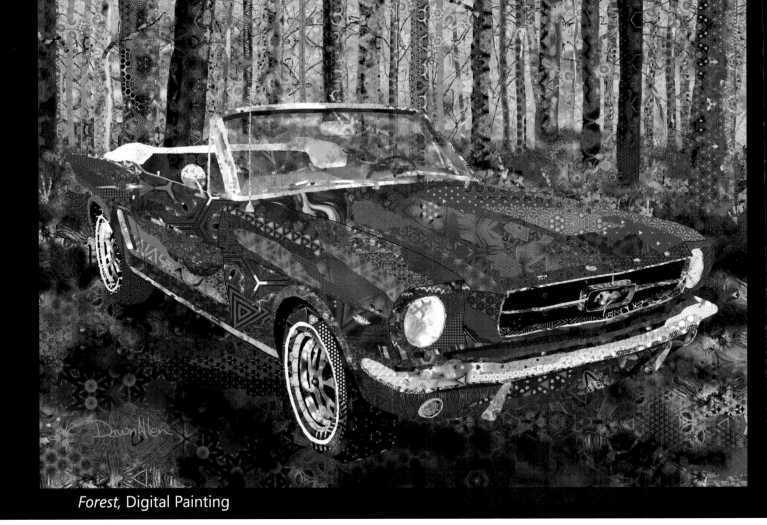

Forest, Digital Painting

Missouri

I had a client commission this car portrait, and she requested a forest from her state, Missouri. Too bad I didn't get to deliver it in person. I love forests (as I am sure you have gathered), and my husband would have loved some of their famous barbeque and beer.

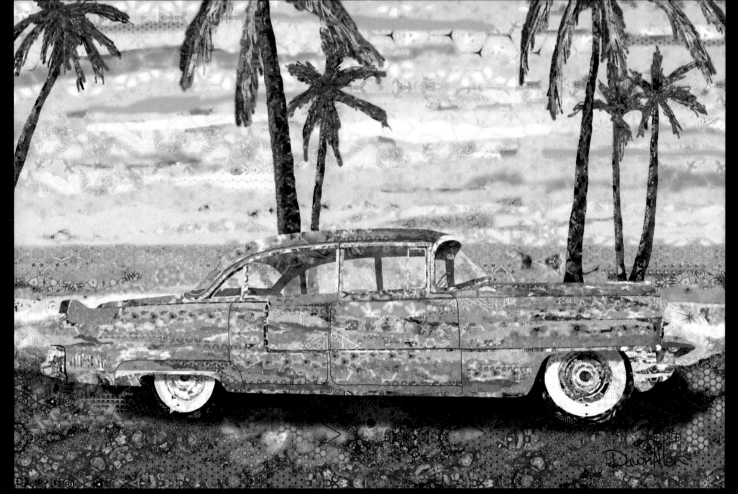

Pink Classic, Digital Painting

Texas

Amarillo, Texas, the "Helium Capital of the World," is home to the U.S. National Helium Reserve, a vast underground storehouse. The government created the Federal Helium Program in 1917 to provide helium for blimps during World War I.

It never occurred to me that there would be a stockpile of helium. I researched why helium is important. According to How Stuff Works, "It's believed that the planet's total helium supply is running dry. If our supply ran out, it could spell the end of MRI testing, LCD screens, and birthday-party balloons."

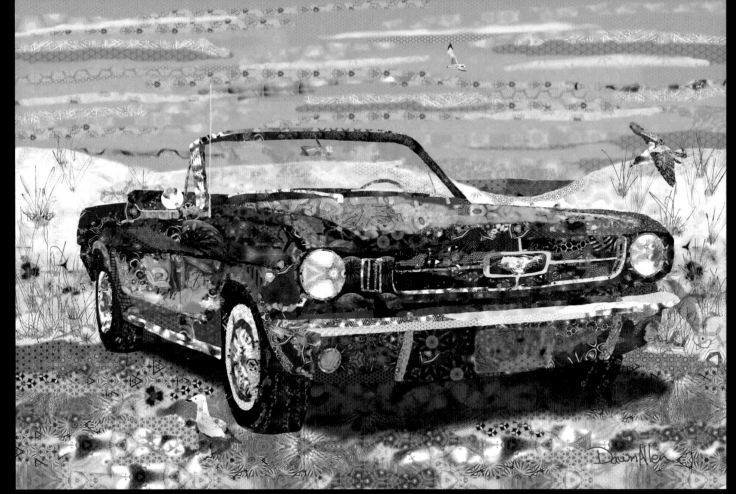

Gulls and Dunes, Digital Painting

Georgia

As I mentioned, when I was writing my *Great American Road Trip* email adventure, one of the things I liked to investigate was funny old state laws. Georgia has one near and dear to my heart: "It is illegal to keep donkeys in bathtubs." Well, I have two donkeys and I can tell you, good luck getting a donkey into your bathtub in the first place! Even if you have an outdoor bathtub, I think it might need to be full of apples to coax them in.

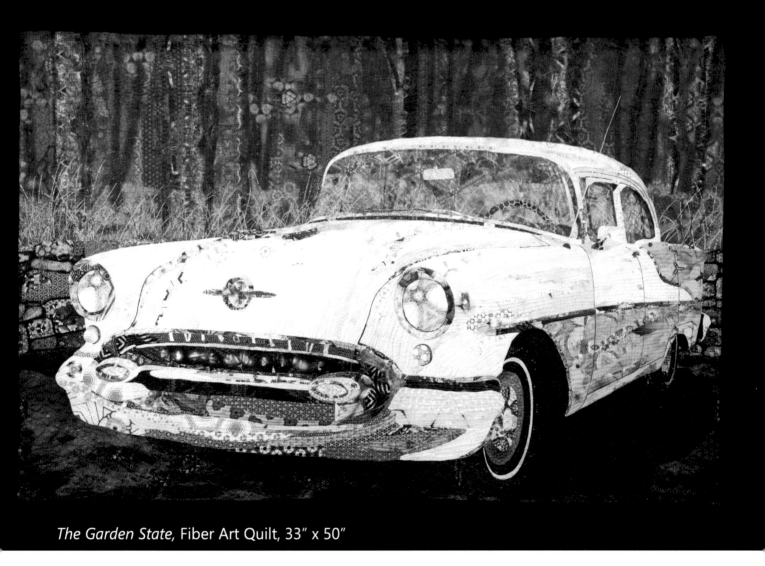

The Garden State, Fiber Art Quilt, 33" x 50"

New Jersey

Our family started a tradition of vacationing at the Jersey Shore. My kids love the boardwalks, amusement parks, and ocean beaches. It makes for a fantastic family trip. New Jersey is really a surprising state because some parts are very urban and busy, but for many miles you can drive through forest or visit quiet beach preserves. I know a lot of people like New Jersey for its proximity to New York City, but I love it for its beaches.

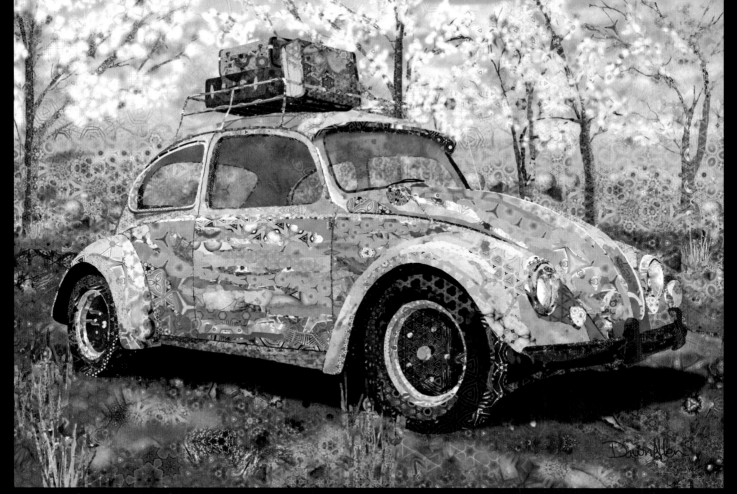

Spring Iris, Digital Painting

I was really excited when a client commissioned me to paint this car. We were at a car show, so I was able to take my own reference photos. I love their luggage on top and the fun lights in front. The car's name is Iris, which inspired the springtime scene with iris flowers in front.

Montana

If I ever get to Montana, I will head straight for Glacier National Park, a 1,583-square-mile wilderness area with mountains and glaciers. I am most interested in seeing the fields of wildflowers. I have a passion for wildflowers and am currently working on an expansive fiber art project focused on our local wildflowers.

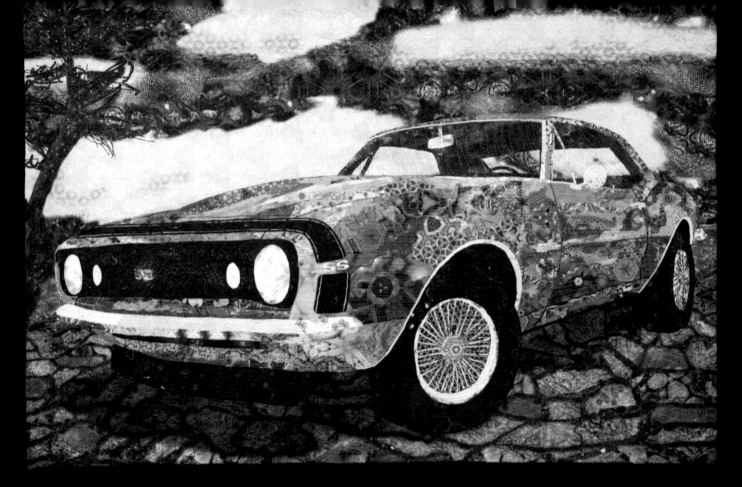

Desert Mud Cracks, Fiber Art Quilt, 33" x 50"

Utah

I have always been fascinated by the look of mud cracks. I usually think of them in sports car or truck commercials on TV. So, when I was drawing this car I thought they would make the perfect backdrop. I did some research on where I could go to see a mud crack desert in person, and it looks like Utah would be a good option. I have always wanted to go there to see the red rocks. Let's keep this state on the short list for must see!

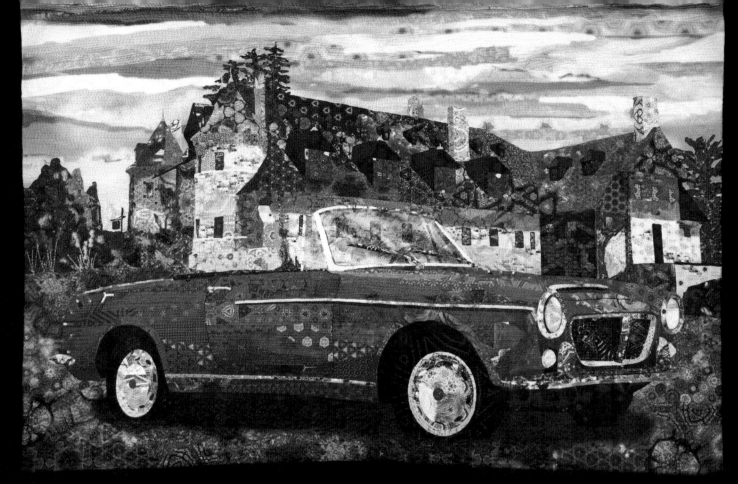

Italian Day, Fiber Art Quilt, 33" x 50"

In order to get good reference photos of all these vintage cars, I started attending car shows. My husband was shocked. I went from a person who could care less about cars to someone searching for the next car show in my area and rearranging my schedule for it. Then I took things to the next level and purchased a 10'x10' tent for displaying art and started going to car shows as a vendor, offering custom portraits of cars and selling prints of my work. It was such fun! I was commissioned to draw this car in front of the Larz Anderson Museum in eastern Massachusetts (one of the locations of the many car shows I attended).

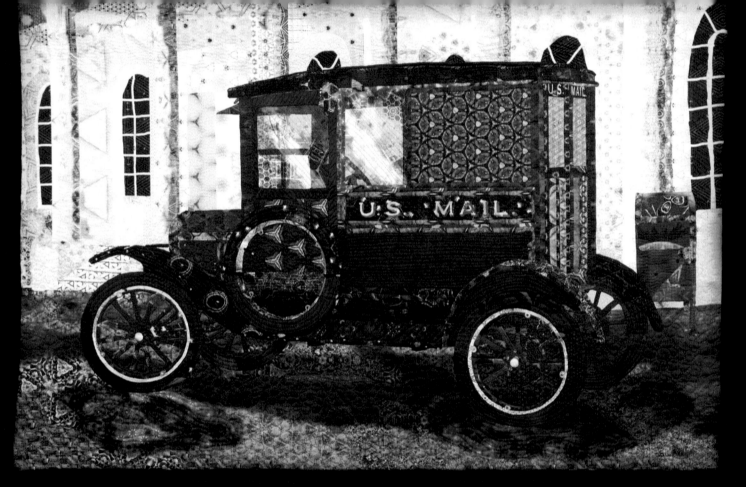

Mail Truck, Fiber Art Quilt, 33" x 50"

Mississipi

In Mississippi the first female rural mail carrier in the United States was Mamie Thomas, delivering mail by buggy in 1914.

When I was in kindergarten and first grade, I was homeschooled. I had some other homeschooled friends a bit older than I, and I remember spending way too long having speed-spelling contests for M-I-S-S-I-S-S-I-P-P-I! I don't even think that I knew that Mississipi was a state or a place. I just knew it was a really long cool word to spell as quickly as possible.

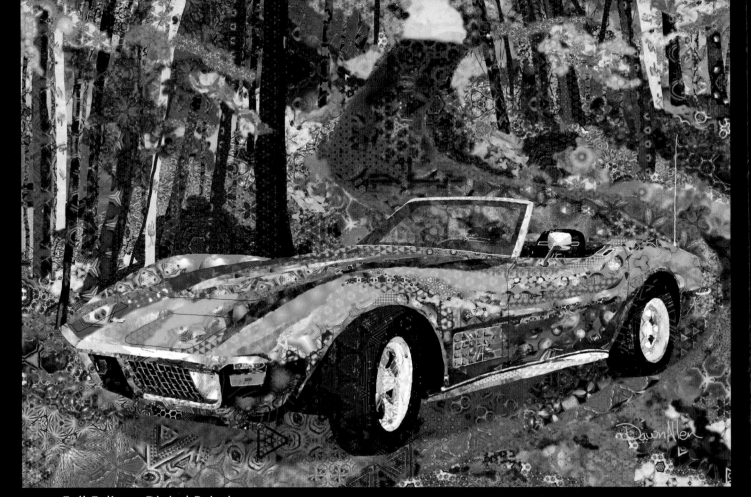

Fall Foliage, Digital Painting

Tennessee

The most visited national park in the United States is Great Smoky Mountains National Park in Tennessee, with 11.4 million visitors each year. I need to be one of those visitors someday. When driving through the state I was wowed by the green ancient rolling mountains.

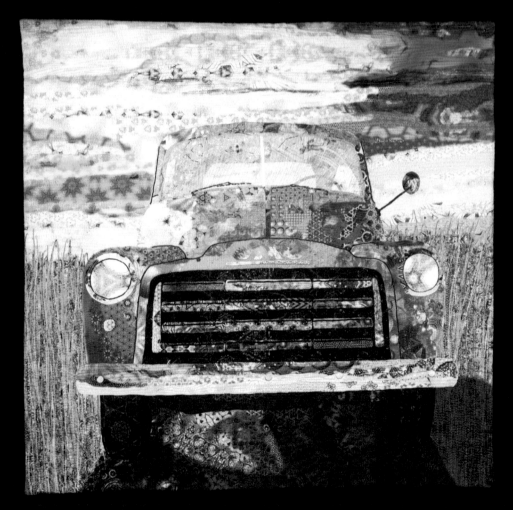

Amber Waves, Fiber Art Quilt, 33" x 33"

North Dakota

North Dakota is one of the leading wheat growers in the United States. I always wondered why people didn't grow their own wheat until I realized how big your field would need to be to make a loaf of bread! But there is another reason: in the 1930s, a law was enacted that prohibited US citizens from growing wheat at home unless the crop was properly documented and the associated fees were paid.

I don't eat wheat because I am gluten intolerant. It has been 15 years, and the only thing I still miss is pizza—gluten-free crusts just aren't the same.

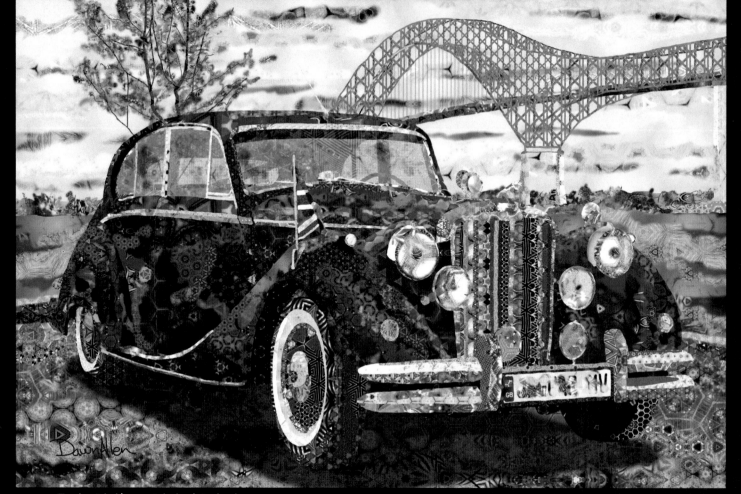

Trois-Rivières, Digital Painting

Canada

I didn't set out to cross international borders on my road trip, but two commissions took me on great artistic adventures. The first stop: Trois-Rivières, Quebec. The customer supplied me with a photo he had taken of his car in front of this iconic bridge. I did move the tree over a few feet but otherwise thought the reference photo provided the perfect inspiring backdrop for the beautiful car.

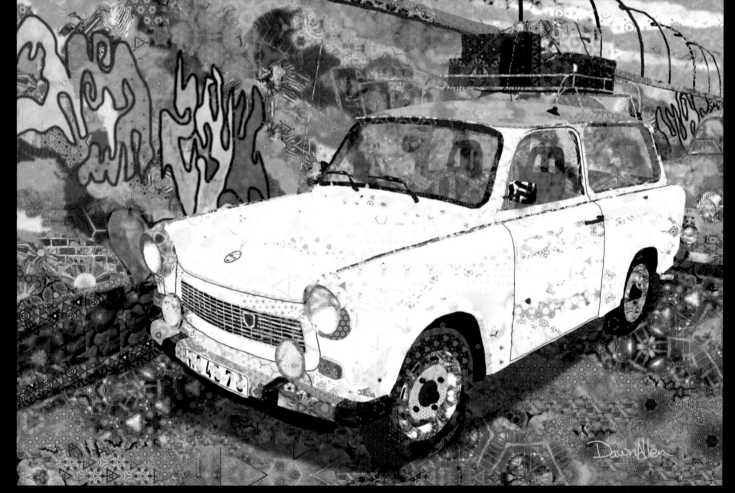

Berlin Wall, Digital Painting

Germany

Then off to Germany! I never expected to use the Berlin Wall as a background in my road trip, but it was a fun challenge. This is an East German car built the year the wall came down. I photographed my client's car at a car show and then did some online research to get an idea of what the wall looked like. It was a fun challenge!

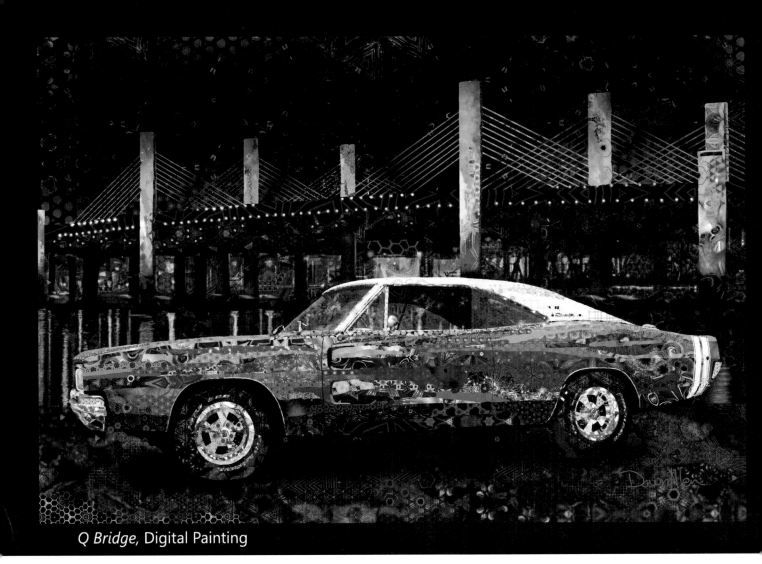

Q Bridge, Digital Painting

Thank you for joining me on my *Great American Road Trip*! Despite having created over 75 vintage car pieces, I feel there is still more to explore on this subject of cars and travel. If you are interested in commissioning a portrait of your car, please contact me through my website, dawnallen.net. I would be thrilled to create a special piece for you.

It is time to continue moving forward with other creative endeavors as well, but I hope that someday I will get out there and do a real live *Great American Road Trip*.

As I said at the end of each of my emails, see you at the next stop!

DawnAllen

74

State/Country Index

Originals and prints from the *Great American Road Trip* are available at dawnallen.net

The Art of Meditating with Cats and *Garden Blooms* as well as other books by Dawn Allen are also available at dawnallen.net

Art Index